IMAGES
of Rail

THE NEW YORK
CENTRAL SYSTEM

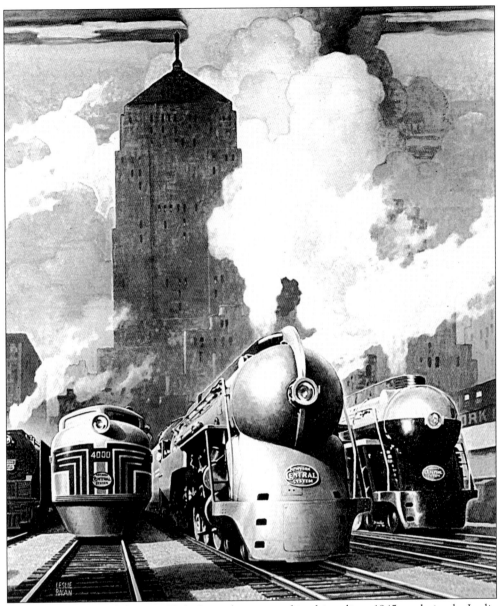

The forward vision of the New York Central is captured in this valiant 1945 rendering by Leslie Ragan. The hallmark trains of the "Great Steel Fleet" are depicted leaving Chicago's LaSalle Street Station. Both steam and diesel are featured in a robust depiction of a triumphant America surging into post–World War II modernism.

On the cover: The 20th Century Limited steams along the Hudson River near Garrison, New York, in June 1938. (Courtesy Jeff Hands.)

IMAGES
of Rail

THE NEW YORK
CENTRAL SYSTEM

Michael Leavy

ARCADIA
PUBLISHING

Published by Arcadia Publishing
Charleston, South Carolina

Printed in the United States of America

Library of Congress Catalog Card Number: 2006931501

For all general information contact Arcadia Publishing at:
Telephone 843-853-2070
Fax 843-853-0044
E-mail sales@arcadiapublishing.com
For customer service and orders:
Toll-Free 1-888-313-2665

Visit us on the Internet at www.arcadiapublishing.com

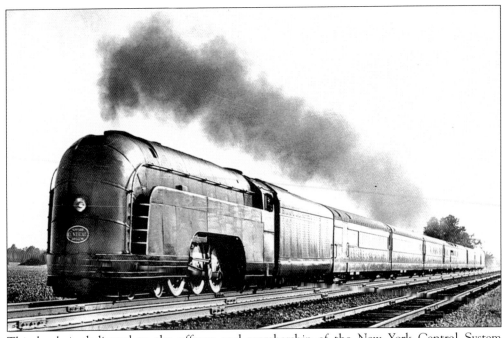

This book is dedicated to the officers and membership of the New York Central System Historical Society (NYCSHS). Their dedication and hard work in maintaining the artifacts, drawings, photographs, and memorabilia of this great American railroad adventure will keep the "Headlight" burning well into the future. Here the Mercury, a radical Cleveland-Detroit speedster, steams out of Cleveland, Ohio, in May 1937. (Photograph by Andrew Hriz, collection of Bruce Young; courtesy NYCSHS.)

CONTENTS

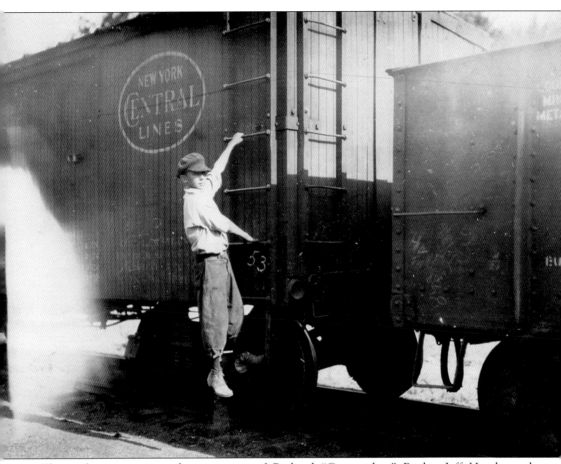

The author appreciates the assistance of Richard "Commodore" Panke, Jeff Hands, and Donovan Shilling. Special thanks to the New York Central System Historical Society for use of photographs from its vast collections. The boy on the boxcar ladder claimed he worked for the railroad. This photograph by Lewis W. Hine was taken in Mountain Grove, Missouri, on August 15, 1916. (Courtesy Library of Congress.)

INTRODUCTION

Before Cornelius "Commodore" Vanderbilt turned his gaze from his opulent Hudson River ferries to that new contrivance, the railroad, George Featherstonaugh was already pursuing his dream of a railroad in New York. In 1831, the Mohawk and Hudson began passenger service between Albany and Schenectady. There was resentment not only from politicians worried about threats to their precious Erie Canal but from citizens as well. A contemporary would write, "Canals, sir, are God's own highway, operating on the soft bosom of the fluid that comes straight from heaven. The railroad stems direct from hell. It is the devil's own invention, compounded of fire, smoke, soot and dirt—spreading its infernal poison throughout the fair countryside."

The benefits of transportation by train were obvious, especially to transcontinental travelers weary of stagecoaches and slow canal boats. The rapid chartering of railroads indicated they would be the engines of economic growth for an impatient country entering the Industrial Revolution. By 1851, a total of 10 railroads haphazardly linked Albany to Buffalo. In 1853, they were consolidated into the New York Central Railroad Company, the fulfillment of a dream by Erastus Corning, founder, first president, and driving force of the railroad. Shipping mogul Cornelius Vanderbilt was in his mid-60s when he fully entered the railroad craze sweeping the nation. He acquired control of the New York Central in 1867 by driving down its stock. In 1869, he merged it with his Hudson River Railroad, forming the New York Central and Hudson River Railroad. An uninterrupted route from New York City to Buffalo would form the nucleus of the Vanderbilt family's railroad empire.

Sensitive to the yearnings of a restless America, the Vanderbilts introduced remarkable improvements and standardization of track gauges and equipment. Towns sprang up along the main line just to service the railroad. Locomotives became bigger and more powerful with demand; passenger cars became luxurious "hotels on wheels," not unlike staterooms on riverboats. Magnificent railroad stations made passengers feel like royalty. Other lines, some quite large, were absorbed through outright purchase, leasing, or controlling interest through stocks. In 1911, the New York Central and the Lake Shore and Michigan Southern merged to form the New York Central, variously known as the New York Central System and New York Central Lines.

Among the lines to enter the orbit of the "System" were the Cleveland, Cincinnati, Chicago and St. Louis (Big Four), the Pittsburgh and Lake Erie; the Boston and Albany; and the Indiana Harbor Belt. By the late 1920s, and after subsequent presidents, the Central ran through 11 states and two Canadian provinces, with a road mileage of 11,500.

Through war, depression, and peace, the Central guided America with its own form of optimism, projecting positive, mighty, and inspirational concepts. The "Great Steel Fleet,"

"Roll out the Red Carpet," and "This place is as busy as Grand Central" entered regularly into everyday conversations. Children ran across their fields to see the glamorous Mercury, with its illuminated wheels, race through the twilight. Wives and children of Central employees saved to get dad the best Railroad Standard watch they could afford. Along with its grime, noise, and pollution came architectural masterpieces, fabulous artwork, technological advancements, and an industrial might that jabbed fist-like at an uncertain future.

The coming of the super-highway, long haul trucking, and airline travel would eventually erode the rail system, and in 1968, it was merged into archrival Pennsylvania Railroad. The new Penn-Central would soon fail. The Central's end was undignified. Now a few names of its famous flyers are attached to Amtrak trains.

The lingering glory of the railroad refuses to pass from modern reflection. Just when we feel it fading away or becoming some strange historic chapter, a new generation of rail fans has emerged to give it a fresh look. This book hopes to capture not only its enduring romance and lore but also the significance this dynamic and forward-looking enterprise had in building a modern America.

One

THE COMMODORE'S
RIGHT-OF-WAY

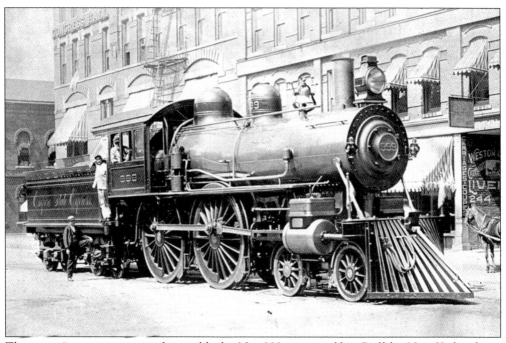

The most famous engine in the world, the No. 999, suns itself in Buffalo, New York, after a historic run on May 10, 1893, between Batavia, New York, and Buffalo when it attained the unprecedented speed of 121.5 miles an hour. It captured the world's imagination; no man-made machine had ever moved so fast. Some consider the specially crafted 4-4-0 the most beautiful locomotive ever built, with polished fittings against a shiny black boiler and its impressive 86-inch drivers. The Vanderbilts, from the very beginning, were not hesitant in making their new railroad the glitziest in America.

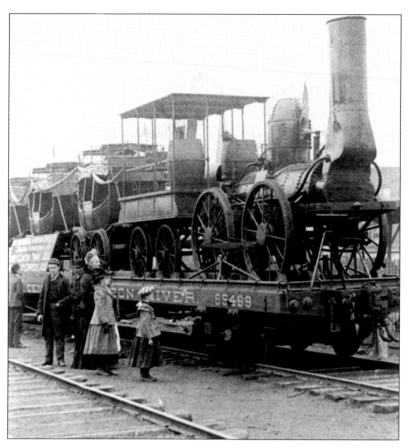

A replica of the DeWitt Clinton rests on a New York Central and Hudson River flatcar, probably at the 1904 Columbian Exposition (Chicago World's Fair). The Mohawk and Hudson Railroad began operation in 1831. It would become one of the 10 original railroads linking Albany to Buffalo, consolidated into the New York Central in 1853.

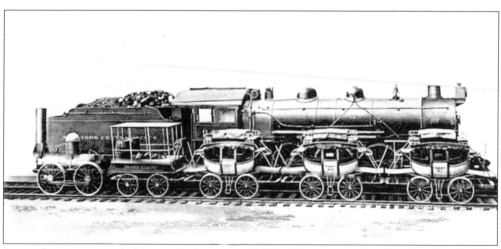

A popular promotional photograph shows the DeWitt Clinton astride a Big Four Pacific. The DeWitt Clinton locomotive weighed 6,758.5 pounds and was just under 12 feet. Steam generated in its tubular longitudinal boiler powered a single cylinder. The stagecoach cars were mounted on rail wheels. This exact replica of the West Albany–built original was the pride of the Central and was displayed on the balcony of Grand Central Terminal.

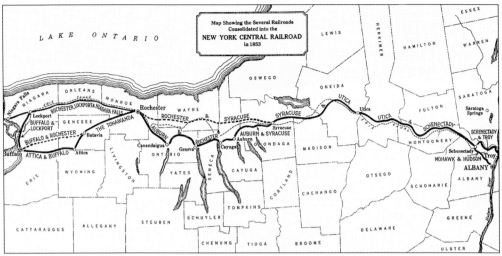

An 1853 map shows the Upstate New York railroads (roughly) linking Albany to Buffalo. They were Albany and Schenectady Railroad; Schenectady and Troy Railroad; Mohawk Valley Railroad; Syracuse and Utica Direct Railroad; Rochester and Syracuse Railroad; Buffalo and Rochester Railroad; Rochester, Lockport and Niagara Falls Railroad; Rochester and Lake Ontario Railroad; Buffalo and Niagara Falls; and the Buffalo and Lockport Railroad. Track gauges and equipment standardizations were immediately implemented.

It is accepted this little Pioneer-style 4-2-0 pulled two cars on the Auburn and Rochester Railroad (later the Rochester and Syracuse Railroad) in the early 1840s. It is pictured in 1872 at the Auburn prison. This probable Norris-built locomotive gives a rare look at the early locomotive power of the 1830s and 1840s.

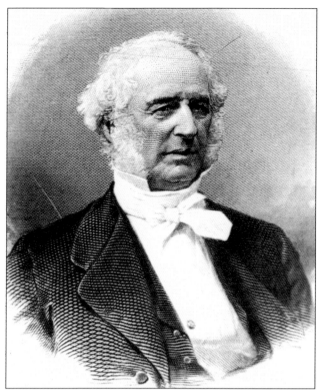

Cornelius "Commodore" Vanderbilt (1794–1877) was operating his own ferry freight business along the New York City waterfront when he was 16. He became director of the Long Island Railroad in 1844. It was said he was vulgar, ruthless, virtually friendless, and nasty to everyone—including his family. He acquired the New York Central in the 1860s and merged it with his Hudson River Railroad in 1869. His dream of an uninterrupted route from New York City to Buffalo was realized. It was only the beginning, as he methodically accumulated more railroads.

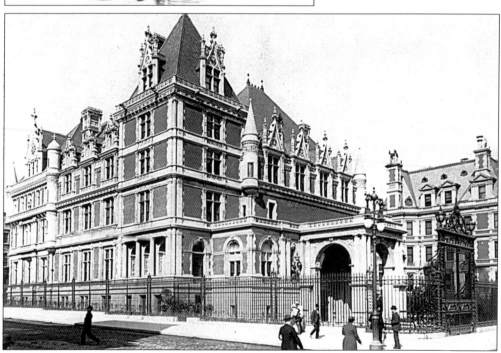

Commodore's New York City mansion, pictured in 1894, was a Baroque masterpiece. Some considered it "modest" in light of the man's wealth. It was said he lived frugally and when he died, his estate was estimated at $100 million.

William Henry Vanderbilt, (1821–1885) inherited the bulk of his father's estate and doubled it to $200 million by the time of his death nine years later. With his other brothers disinherited and his sisters receiving very little of the estate, William, as president of the railroad, vastly expanded the family's railroad empire. His "public be damned" response to a reporter's question dogged him until his death in spite of his philanthropic pursuits.

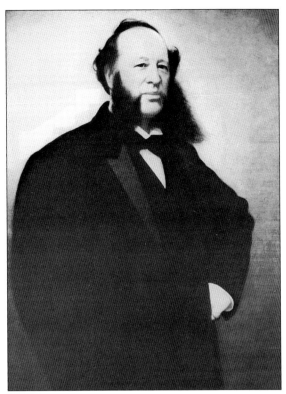

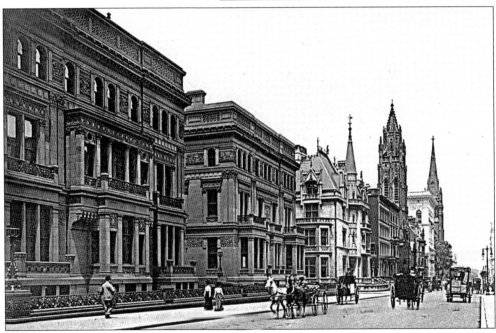

William's Fifth Avenue residence is comprised of the two facades on the left, joined by a center section. Critics of the day said it was gloomy, oppressive, and over-decorated. Envy and jealousy may have inspired those observations. There is another Vanderbilt family residence just beyond it. (Courtesy Library of Congress.)

A photograph from the 1850s shows the *Armenia* built by Rodgers for the New York and Harlem Railroad. The little railroad, incorporated in 1831, ran seven miles from Manhattanville to 135th Street in Harlem. It was Cornelius Vanderbilt's first investment, and he became its president in 1867. In 1873, he incorporated it into his New York and Hudson River Railroad.

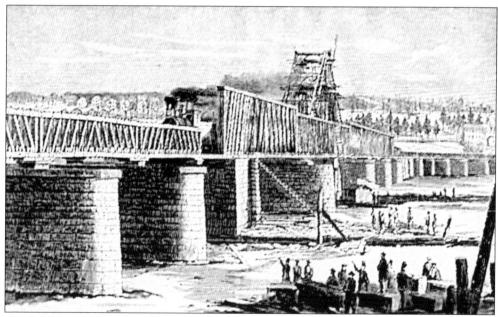

Vanderbilt's empire required the acquisition of railroads that, individually, were modest but when connected formed a formidable system. Crossing the Hudson was fundamental to this grand design, and it was across the Albany Bridge, depicted here in 1866, that Vanderbilt was able to project his railroad toward the promise of the west.

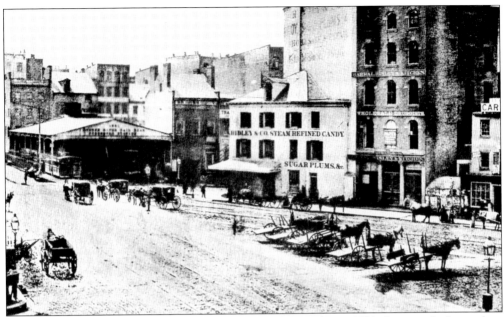

The Hudson River Railroad terminal shed is to the left in this *c.* 1851 photograph. It stood on the corner of Chamber Street and West Broadway in New York City. Only horse-drawn cars were allowed to this location. Steam engines were forbidden, being restricted to the city's first roundhouse and service yard at 33rd Street.

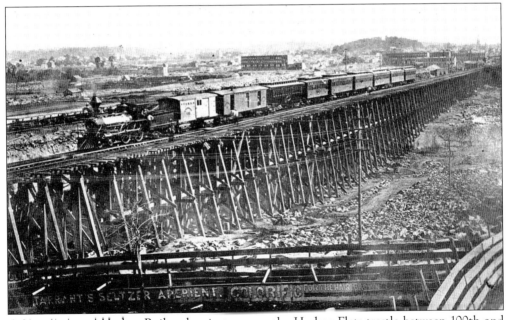

A New York and Harlem Railroad train traverses the Harlem Flats trestle between 100th and 116th Streets in New York City in the 1870s. The line, taken over by the Central, is considered America's first streetcar railroad, using horsecars to link Lower Manhattan and Harlem. Chartered in 1831, it systematically extended to Fourth Avenue, Grand Central, Yorkville, the Bowery, city hall, White Plains, Croton Falls, Astor House, and Broadway.

This temple-style "through" station for the Syracuse and Utica Railroad was built at Vanderbilt Square in Syracuse in 1839. A bell on the roof announced arrivals and departures. President Lincoln was among the more noted historical figures to pass through here. The station was demolished in 1869.

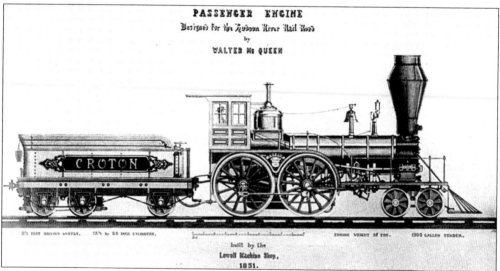

As railroad fever spread across America and Europe, promoters and investors insisted on artistic touches. The modern *Croton*, designed for the Hudson River Railroad in 1851, weighed 15 tons, and the tender held 1,300 gallons of water. Decorative flourishes abound at a time when a still young and culturally insecure America looked to Europe for cultural guidance in manners of art, music, dress, and architecture.

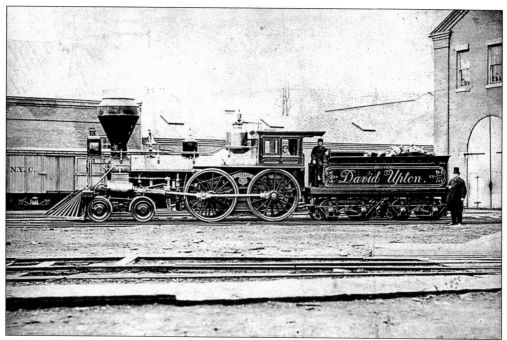

The *David Upton*, a wood-burning balloon stacked beauty is at the Central's Brown Street facilities in Rochester around the time of the Civil War. Even during war the desire to decorate could not be resisted. Hand-painted frescoes, polished brass, and wrought iron ornamentation contrasted beautifully against the blue cast of the Russian iron boiler jacket. The cabs and pilots (cow catchers) were often painted red or green.

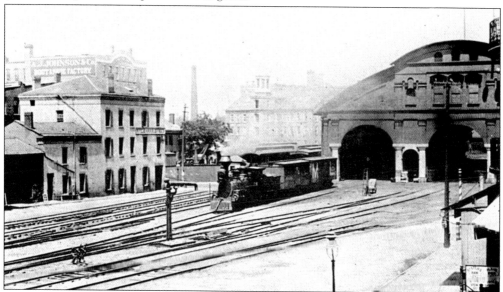

The ticket office and headquarters for Rochester's Mill Street station were located in the light-colored brick building to the left in this c. 1870 stereographic view. Diamond-stacked No. 166 is departing the massive train shed. President Lincoln addressed the citizens here during his inaugural ride in 1861. His funeral train would stop in 1865. This site was developed in 1853 for $10,000. Passengers boasted about their rapid 36-hour ride from Rochester to Albany.

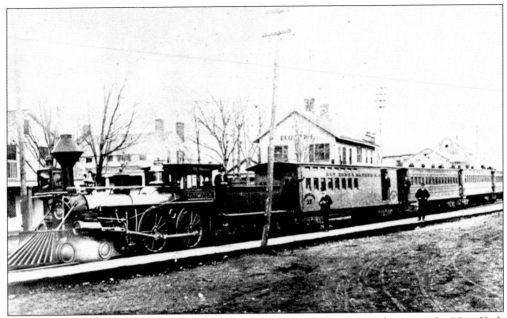

The *Troy* and its train of flat-topped coaches are outside the Chatham depot on the New York and Harlem Railroad sometime in the 1860s. Passenger travel was rough, leading to developments in suspension and ventilation. Although freight and mail were often a railroad's primary source of revenue, many took their passenger service seriously. The *Troy* was likely polished with sperm whale oil for this picture.

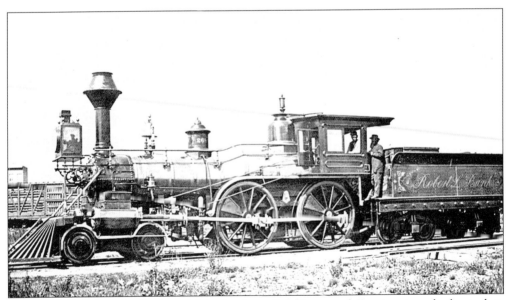

The *c. 1865 Robert L. Banks* exhibits its beautiful blue-toned Russian iron boiler jacket. Americans adapted Russia's technique of hammering graphite powders into the surface of iron sheets to prevent rusting. This created a shimmering blue, sometimes gray, luster that accented the polished brass fittings and extensive hand painting. (Courtesy NYCSHS.)

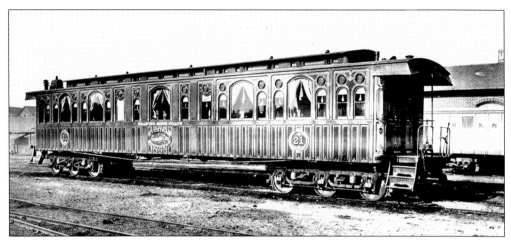

Commodore Vanderbilt helped launch Webster Wagner's sleeping car company by ordering four cars from the former wagon builder shortly after the Civil War. Wagner then organized the New York Central Sleeping Car Company. This Wagner drawing room car was built in 1868 for the Central's Lake Shore and Michigan Railroad. It saw service on the Day Express between Chicago and Cleveland.

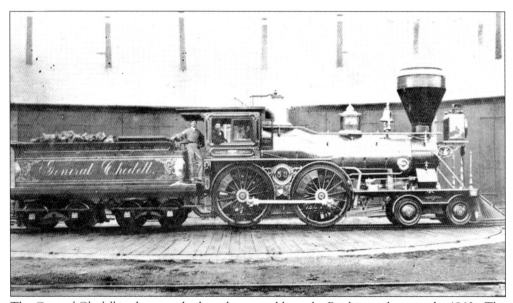

The *General Chedell* is photographed on the turntable at the Rochester shops in the 1860s. The engineer and firemen are in the cab. Rochester was fundamental to the fledgling New York Central. Four of the original 10 railroads terminated here.

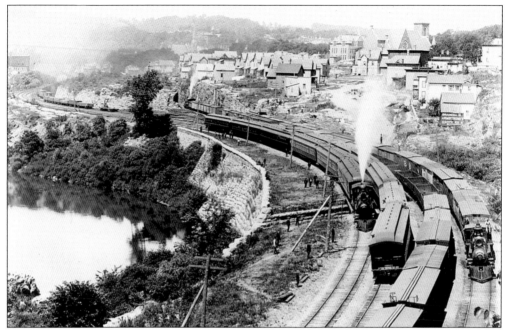

A professional photographer was commissioned to photograph the four-track main line at Little Falls in 1890. The virtually gradeless run from New York City to Buffalo earned the name the "Water Level Route." The Mohawk River is to the left. The four tracks presented problems during heavy snowfalls. Plows would push the snow onto the adjacent tracks.

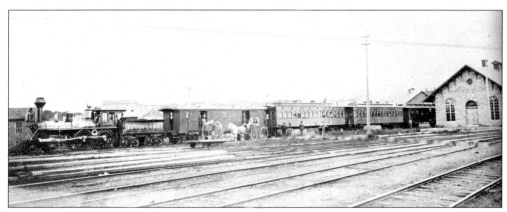

The Rome, Watertown, and Ogdensburg Railroad, pictured in 1878, was taken over in 1891. Nicknamed the "Hojack Line," an edict from the Central's hierarchy forbade the use of the word Hojack. It had become so ingrained in the folklore of the region, however, that the edict was ignored. It persists to this day even after having passed from the Central to the Penn-Central, to Conrail, to CSX.

Standing beside an ancient cobblestone railroad pump house in this 1937 photograph is New York Central vice president and railroad historian Edward Hungerford. To his right is Sheldon Fisher, a local historian who fought to save the pump house, which is the second-oldest railroad structure in America. The photograph was taken in Fishers on the Auburn branch. (Courtesy Victor Historical Society.)

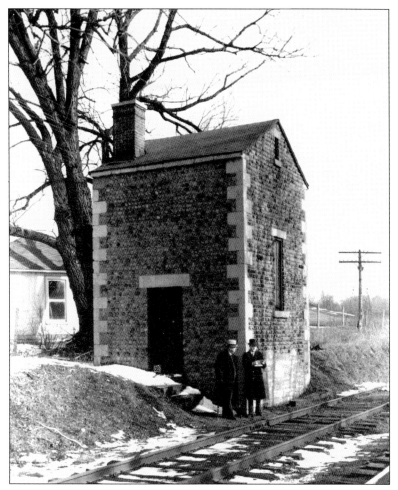

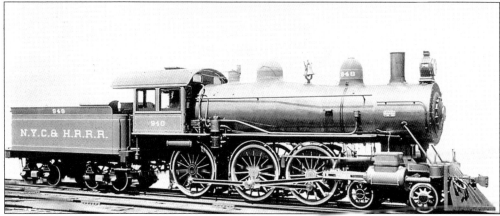

A 10-wheeler with delicate white striping around its domes, tender, and running boards stands for its builders photograph. As the railroad expanded, larger and more powerful engines were required. Towns sprang up along the main line and branches, which generated even more service. Locomotive technicians, striving for efficiency and power, were conscious of design. This 4-6-0 is especially attractive.

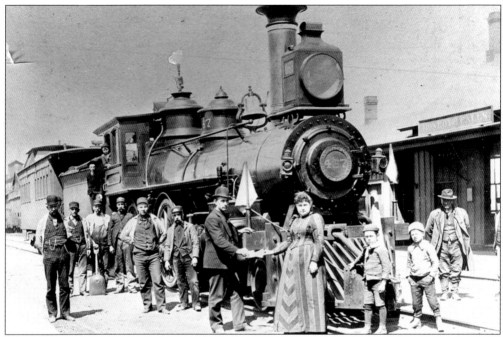

Officials, crew, and locals are involved in some kind of commemoration in Honeoye Falls. The "Peanut Branch" opened in 1853, providing service from Canandaigua to Batavia west to Buffalo. The streets of Honeoye Falls were often clogged with produce wagons from local farmers. (Courtesy Honeoye Falls/Mendon Historical Society.)

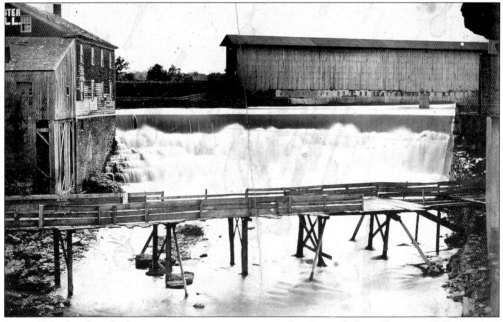

It would be hard to find a more picturesque town on the Central than Honeoye Falls. Tucked away near upstate New York's Finger Lakes District, its mills, falls, and residential streets are, to this day, still lovely. In the distance is the *c.* 1853 covered railroad bridge built by the Central. It was later replaced by a steel span. (Courtesy Honeoye Falls/Mendon Historical Society.)

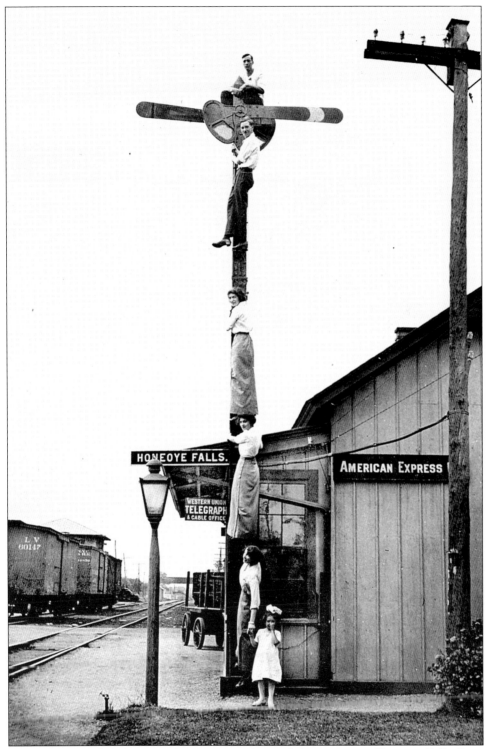

Locals have ascended the semaphore mast in front of the station at Honeoye Falls, Peanut Branch for this 1920s photograph. (Courtesy Honeoye Falls/Mendon Historical Society.)

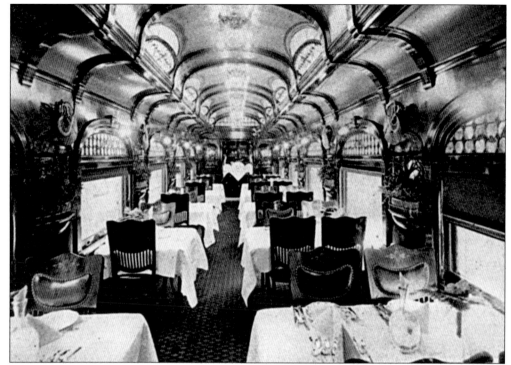

The Central handled its own dinning cars on its more famous named trains. Pullman managed the sleepers and parlor cars. This richly appointed dinning car reflects the height of Gilded-Age opulence with its highly polished brass fittings, linen tableware, stained-glass windows, chandeliers, fine dinnerware, and exotic hardwoods. Some passenger trains barely broke even, but the prestige they afforded the railroad made it a fair trade-off.

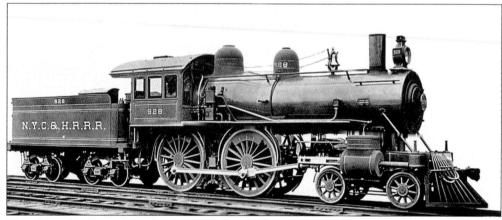

The classical styling of this Buchanan I-class high-stepping sister of No. 999 is still appealing. Simple, clean, and straightforward, it pulled its share of "varnish"—highly polished wood passenger cars—along the famed Water Level Route. In 1914, the railroad's name was changed from New York Central and Hudson River Railroad to the New York Central Railroad.

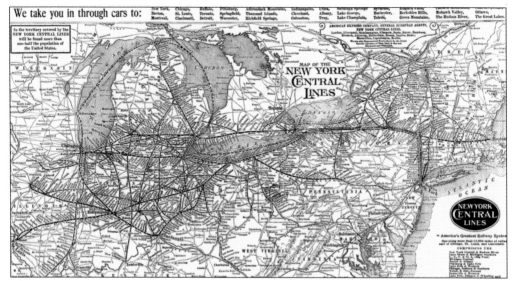

The monolithic expansion into territories that would serve one half the population of the United States is detailed in this 1918 map. Among the substantial railroads controlled by the New York Central were the Lake Shore and Michigan Southern: Cleveland, Cincinnati, Chicago (C.C.C.), and St. Louis (Big Four); Boston and Albany; Pittsburgh and Lake Erie; Lake Erie and Western; Chicago, Indiana and Southern; and the New York and Ottawa Railroad.

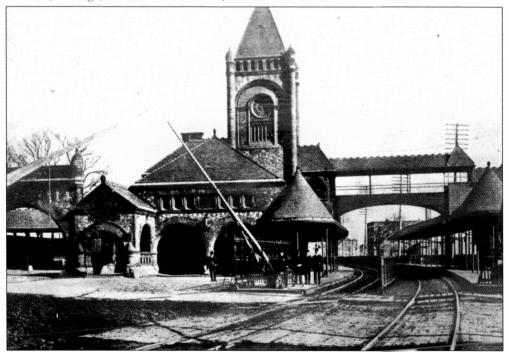

The firm of Robertson and Manning achieved something of an architectural fantasy in their 138th Street Station in the Bronx. Five miles from Grand Central Terminal, it was the first stop after crossing the Harlem River on the Harlem Division. The station's Gothic Revival elements project a medieval mood, but it avoids being oppressive by open platforms, bridges, towers, delicate wrought iron, and open archways.

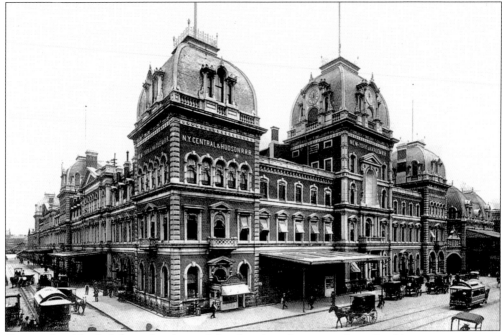

Commodore Vanderbilt used architect John Snook and engineer Isaac Buckhout to construct a station to showcase his expanding empire. Completed in 1871, the second Grand Central Depot was the largest railroad facility in the world. The L-shaped station with its three mansard-roofed towers ran along 42nd Street and Vanderbilt Avenue. Vanderbilt was an admirer of the French Classical style, and his station would bear a resemblance to the Lourve.

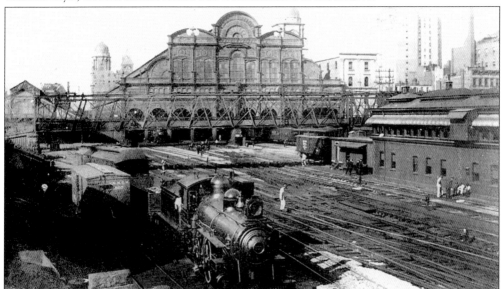

The acres of yard outside the train shed were a headache to New Yorkers. A precision "flying switch" system was used to reduce engine activity. As trains accelerated out of the Park Avenue tunnel, a brakeman released the coupler between the engine and first car. A switchman in the control tower opened a switch, steering the engine to a siding and then immediately closed the switch so the cars could glide into the shed.

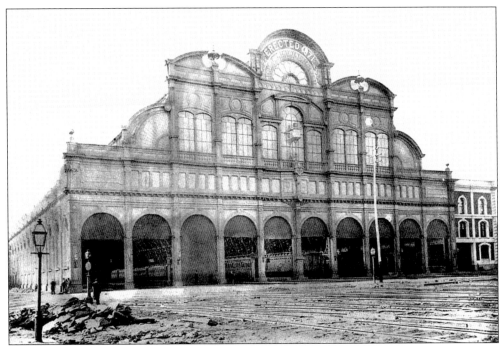

Vanderbilt could not resist modeling his train shed or "head house" after London's Crystal Palace. Even its massive iron trusses were forged in England. Public outcries over pollution, backups, and accidents resulted in lowering tracks approaching the terminal between 45th and 67th Streets. Two tracks ran down the center of 4th Street along a beam tunnel. Attractive footbridges and decorative iron ventilation rectangles made things somewhat more bearable.

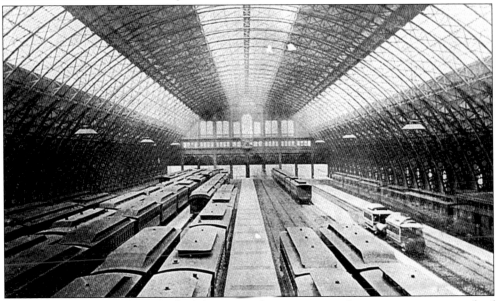

The wonder of its age, the train shed drew gasps from passengers. It was a two-acre network of iron and glass spanning 17 tracks, all of it free standing. It soared to 100 feet at its center and was 600 feet long. The shed and station were second only to the U.S. Capitol in grandeur—and it was inadequate almost from the day it opened!

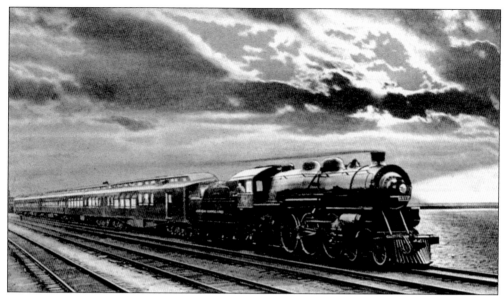

A 1913 postcard of the world-famous 20th Century Limited speeding along Lake Erie combined the talents of photographer, artist, and printer. The train was photographed parked—during the day. An artist painted in the vivid moonlit sky and Lake Erie. A printer then carefully used color separations to create the dramatic glow.

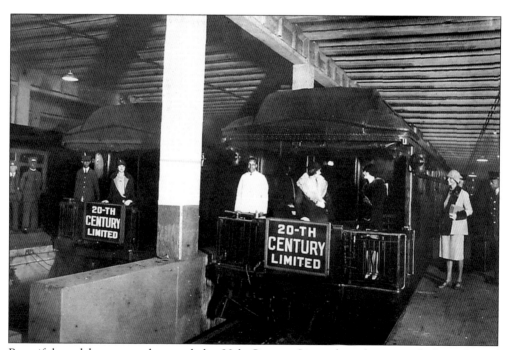

Beautiful models are posed around the 20th Century Limited in the open platform days of the 1920s. One can assume from this promotional photograph that the Century advance train will soon be departing, green flags fluttering, to be followed by several "sections." (Courtesy Rochester Chapter National Railway Historical Society.)

A 20th Century Limited advertisement celebrating the train's 50th anniversary captures the excitement of that time. The brainchild of general passenger agent George C. Daniel, the train debuted in 1902, evolving out of the 24-hour New York-Chicago, Lake Shore Limited. The Century became the symbol of hope for a nation still bruised by the Civil War, looking toward the 20th century with optimism. With additional inspiration from the Columbian Exposition, the all Pullman Century defined American luxury service.

A 1905 advertisement finds a family caught up entirely in the excitement of the 20th Century Limited. It has brought dad safely home for Christmas. The boy is thrilled with his push-toy train. There is even a painting of the train on the wall beyond the welcoming wife.

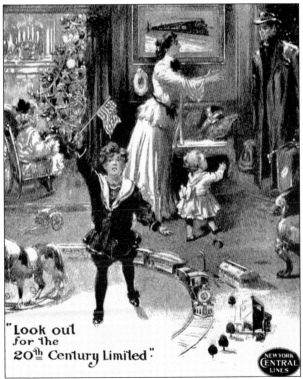

"Look out for the 20th Century Limited."

NEW YORK CENTRAL LINES

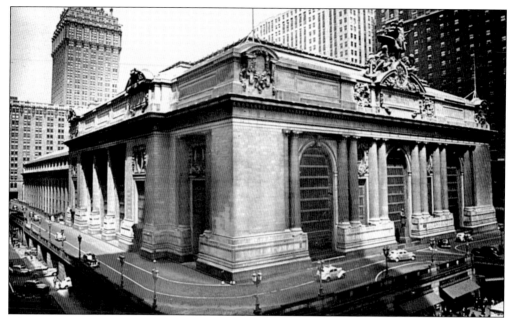

The Grand Central Terminal of today opened in 1913. One of the most colossal urban projects in history, the two-level structure had the tracks lowered below ground to end street-level back-ups. Electric locomotives brought cars in as steam engines were outlawed within city limits. This fabulous granite and limestone terminal represented the impact wealthy railroads had on culture, particularly in shaping urban centers.

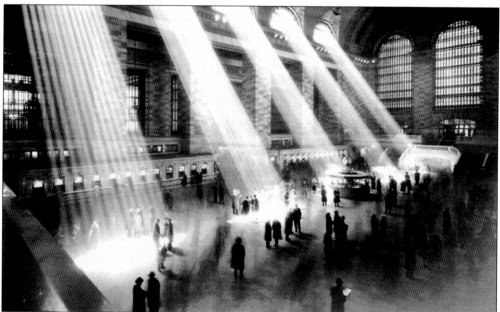

The cathedral-styled concourse is gloriously illuminated with descending shafts of light in this 1937 photograph. The 275-foot-long concourse has, from its opening day, been a kind of meeting square for the people of Manhattan. Amazingly there is a vast city underneath it, filled with businesses, walkways, and railroad facilities. Plans to demolish the terminal were thwarted, in part, by the activism of Jacqueline Kennedy Onnasis.

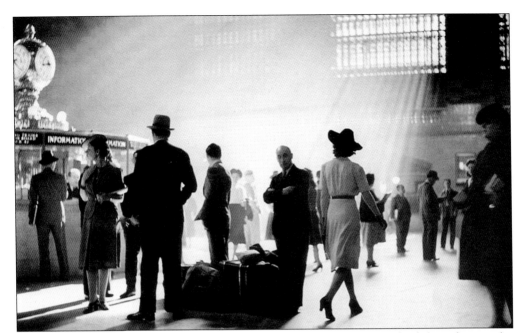

Photographer John Collin took this famous photograph in 1941. To the left is the circular information booth and clock; much-recognized landmarks to millions of travelers. An astronomical mural adorns the vaulted ceiling. Nearly 500,000 people use the terminal today. Half are commuters, the others visitors to New York City.

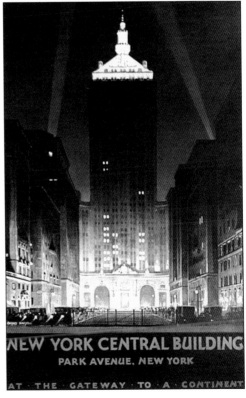

The 34-story New York Central Building, depicted by artist Chesley Bonestell, was the tallest in the never fully realized Grand Central Terminal City originally designed to include commercial and apartment buildings. The plan was to cover the former massive railroad yard in a kind of Renaissance Revival promenade. The elaborate chateau-style roof features a spectacular lantern. Subsequent owners included Harry and Leona Helmsley.

NEW YORK CENTRAL BUILDING
PARK AVENUE, NEW YORK
AT · THE · GATEWAY · TO · A · CONTINENT

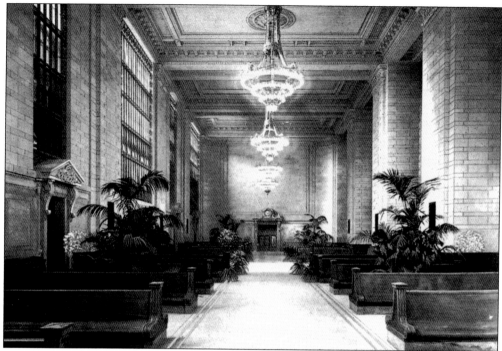

Grand staircases lead to a balcony, train concourses, galleries, and waiting rooms such as Vanderbilt Hall, pictured here around 1914. The ambitious bi-level station took a decade to build. Electrification of the approaches to the station resolved pollution problems. The former street-level tracks and platforms were covered over, creating valuable real estate that was sold or leased.

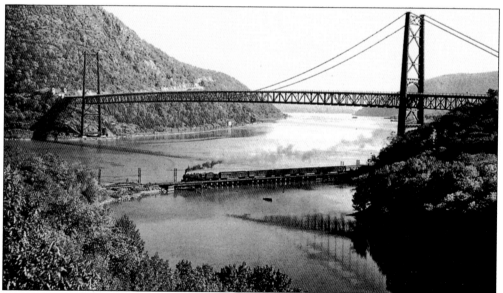

A dramatic photograph of the Hudson River taken from Fort Montgomery shows a consist on the West Shore steaming under the Bear Mountain Bridge. Originally the New York, West Shore, and Buffalo, its Pennsylvania Railroad attachments, intended to compete with the Central's route along the east shore, were not tolerated by William Vanderbilt. He acquired the line in 1886.

Two

THE WATER LEVEL ROUTE

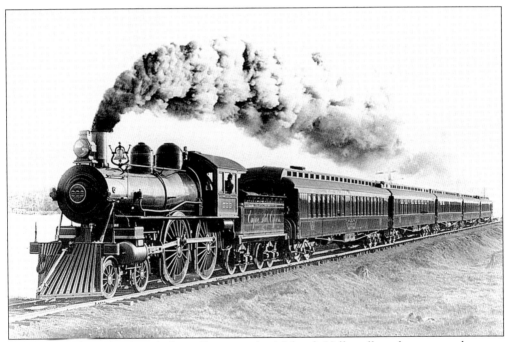

A single break in the Appalachian Range at the Mohawk Valley allowed access to the west. The Erie Canal was dug through first. Its phenomenal success did not go unnoticed by those interested in railroads. When Commodore Vanderbilt connected his Hudson Valley Railroad with his newly acquired New York Central, the stage was set for westward adventuring. A virtually gradeless main line along the Hudson River west to Buffalo became the Water Level Route—the Central's most recognized designation. The route boasted the first long-distance four-track main line in the world. Above, No. 999 steams down that route with five Wagner-built cars.

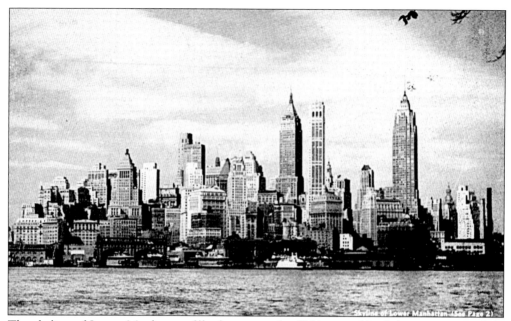

The skyline of Lower Manhattan fills the cover of a 1954 timetable. It lists numerous daily connecting services, through services as well as crack limited, specials, and locals. Pullman, coach, and dining car services are detailed, as are overnight accommodations such as roomettes and bedroom suites.

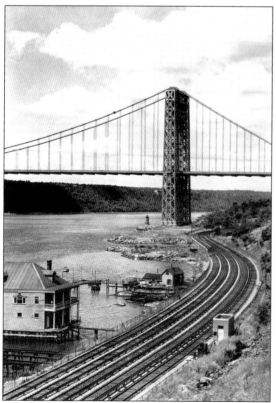

The four-track Water Level Route main line sways gracefully under the George Washington Bridge spanning the Hudson River.

Units from the electric fleet await servicing at the Harmon shops. (Photograph by William W. Rinn; courtesy of the Rochester Chapter NRHS.)

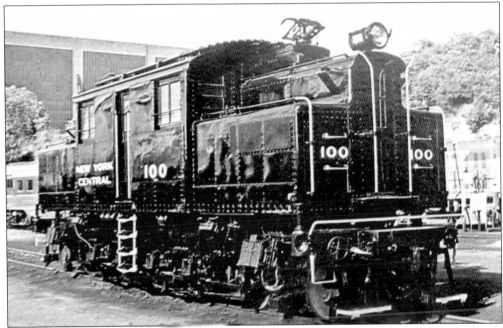

Stout little workhorses like this S-class "Motor" could see 50 years of service. Introduced in 1904 by General Electric, they sometimes pulled the Century and other noted passenger trains in and out of Grand Central. Many boys delighted in finding a Lionel, Ives, or American Flyer tinplate version of this running around the tree on Christmas morning.

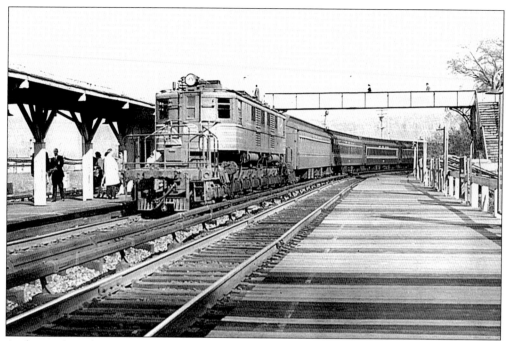

A class P-2b with train No. 838 passes the platform at Spuyten Duyvil in 1963. The train is bound from Poughkeepsie to Grand Central Terminal. (Photograph by George E. Votava; courtesy NYCSHS.)

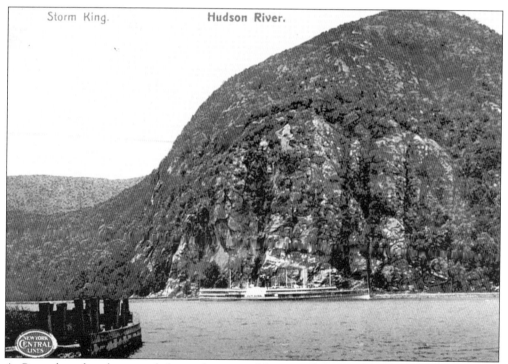

A Central-produced postcard shows the natural beauty of the Hudson highlands passengers could enjoy while traveling the "Scenic" Water Level Route.

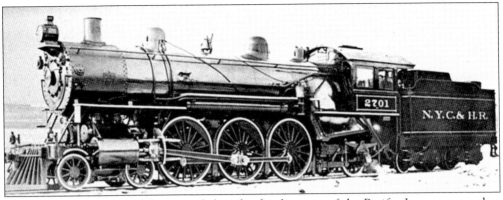

The need for more powerful engines led to the development of the Pacific. In some ways they evolved out of the 10-wheelers, which had heavy use up until the early 1900s. One of the first Pacifics was No. 2701. It started work in 1903. In addition to work along the Water Level Route, it put in a lot of service on the Boston and Albany subsidiary.

In the Mohawk Valley.

Those traveling along the Mohawk River could expect beautiful scenery at almost every turn. A Central-produced postcard shows a tranquil scene in the Mohawk Valley.

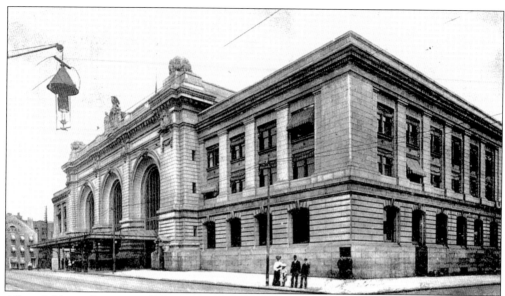

Albany's Union Station is a Beaux-Arts masterpiece wrought in granite. Built by the Central in 1900, it served the capital city until diminished ridership forced its closing in the 1960s. It stood as a vandalized landmark until 1984, when Norstar Bancorp revitalized it as a headquarters. Beaux-Arts makes use of Italian Baroque, French, and Rococo elements as well as sculpture to create bold, imperial structures.

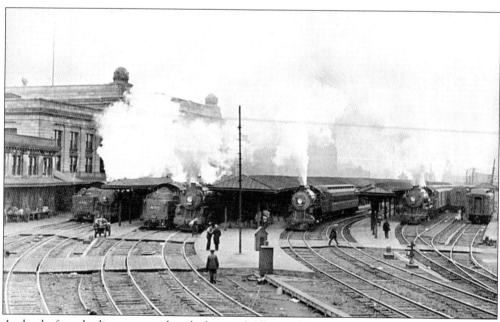

A cloud of smoke lingers over the platforms of Albany's Union Station. The station opened in December 1900 and served the Delaware and Hudson, the New York Central, and the Central's Boston and Albany subsidiary. As many as 121 trains were handled here daily during World War II.

West Albany was a major railroad hub when this photograph of the Central-owned locomotive works was taken in the 1880s. Numerous rail lines converged here, and it was a vast shipping point for livestock and grain. Surrounding neighborhoods were mainly German and Irish immigrants, most of whom worked for the Central. West Albany was home to Erastus Corning, founder and first president of the New York Central.

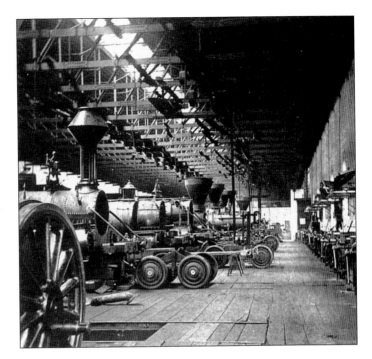

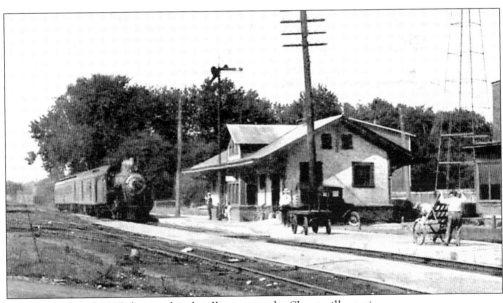

A postcard dated 1925 shows a local pulling up to the Shortsville station.

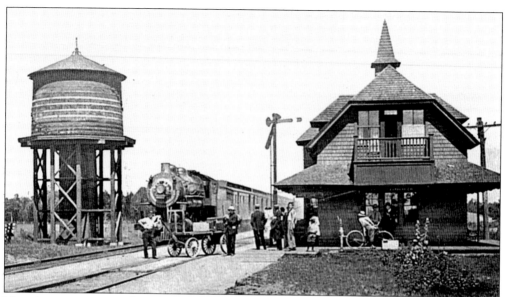

Vacationers arrive at the *c.* 1892 station at White Plain on the Adirondack division. Stationmasters often lived upstairs with their families at these rural locations.

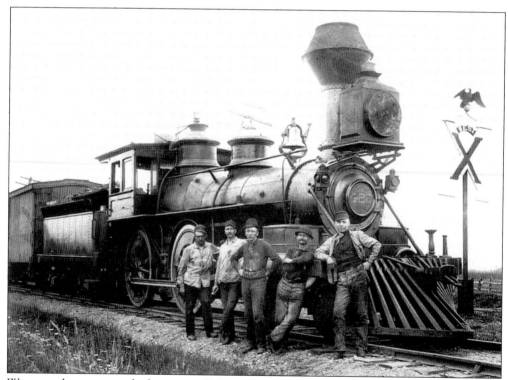

Weary and soot-covered, the crew of No. 422 manages a jaunty pose. The locomotive was built at the Schenectady shops in 1871 for the New York Central and Hudson River Railroad. (Courtesy NYCSHS.)

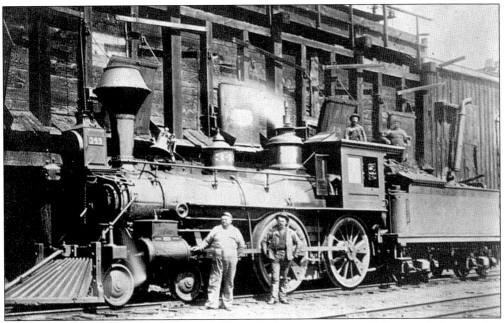

This trusty 4-4-0 has just been fueled and is ready for its assignment. Schenectady Locomotive Works turned out over 100 of these between 1870 and 1873. The premier locomotive manufacturers at the time were Alco (American Locomotive Company), Lima, and Baldwin Locomotive Company. Prominent since the dawn of steam, none was commercially successful in the diesel market. (Courtesy NYCSHS.)

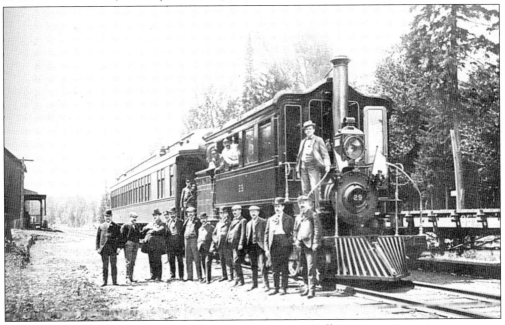

Railroad officials are testing a new Wagner passenger car. Pulling it is an inspection engine or "pony." It is the summer of 1900 at Racquette Lake in New York's Adirondack Mountains. The Central had numerous branch lines and divisions providing service to parks and resorts. They even invested in some of them. (Courtesy NYCSHS.)

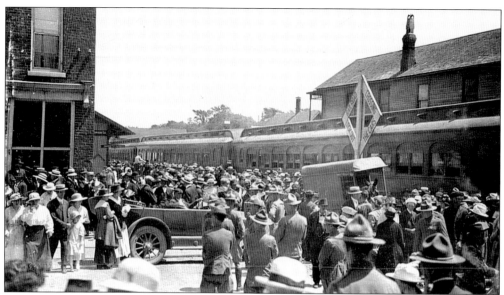

A consist has pulled into the station at Sackets's Harbor, bringing World War I soldiers home to waiting family and friends. (Photograph by George Corby; courtesy Cathy Corby Gardner.)

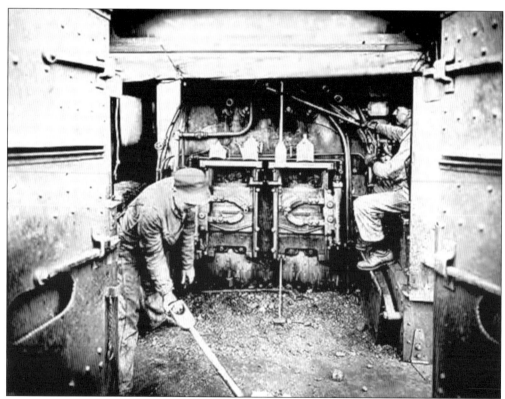

A rare view from back inside the tender shows crewmen, covered with grit and grime, preparing their locomotive for refueling in Syracuse.

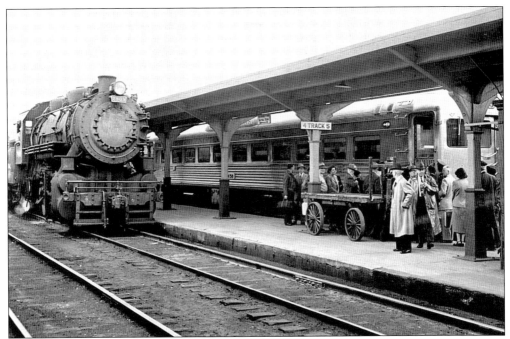

New meets old at Watertown. A steamer pulls astride a new Beeliner, a lightweight powered passenger car used mainly for commuter service. (Courtesy NYCSHS.)

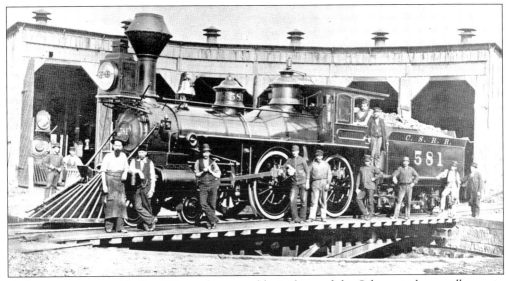

A shop crew poses with No. 581 on the turntable in front of the Schenectady roundhouse in 1879. The engine was built for the Canada Southern, which was financially backed by the New York Central and Hudson River Railroad since its charter in 1871. It was then absorbed by the Central's Michigan Central. Its main line across southern Ontario, Canada, which connected Buffalo with Detroit, became one of the most important routes because of the Niagara Falls trade.

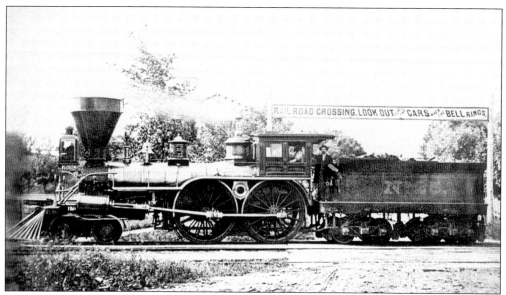

Citizens of Canastota must have welcomed the iron horse to their tranquil community with mixed emotions. Although fascinated by this new technological marvel, they now had to deal with pollution, accidents, and noise. The warning sign in this 1859 photograph reads, "Railroad Crossing, Look Out for the Cars when the Bell Rings."

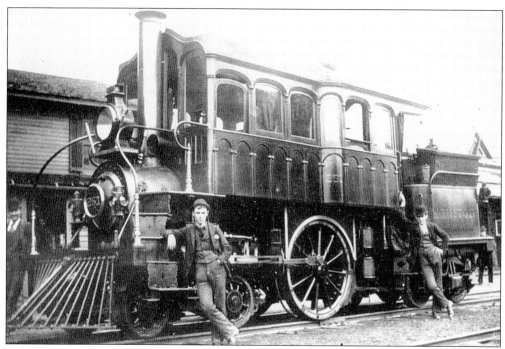

The *Monitor* pony was built at the West Albany shops. Officials inspecting track, signals, and structures were afforded a better view ahead and to the sides because the cab was mounted over the boiler. Inspections engines were proud little vehicles that were often richly appointed. (Courtesy NYCSHS.)

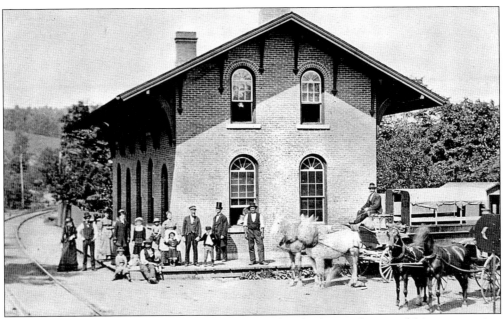

Railroad personnel, their families, and locals pose beside the newly-opened Martisco station in 1870. Martisco is a contraction of Marcellus and Otisco Lake Railway—a short line that would be formed in 1905 to connect the village of Marcellus with this station located two miles from the Central's Auburn Road. Passenger service reached its zenith in the early 1900s. The automobile steadily took its toll, especially after World War II. The last train from Syracuse, New York, departed May 18, 1958. (Courtesy Central New York Chapter, NRHS.)

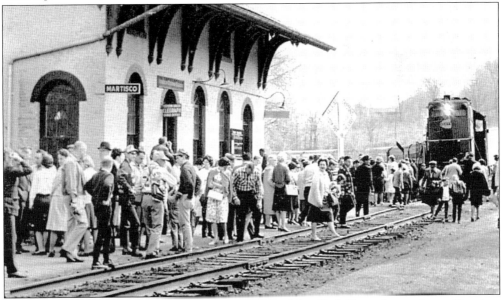

Passengers at the Martisco station are participating in a New York Central excursion to Corning, sponsored by the Central New York NRHS in 1966. The Victorian station was only four walls and a leaking roof when the chapter purchased it in 1966. Restored and filled with railway artifacts, it is now a vibrant museum—a success story when so many similar stations have vanished. (Courtesy Central New York Chapter NRHS.)

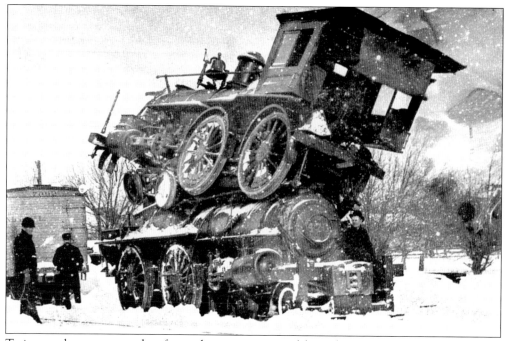

Train travel was promoted as faster than stage or canal boat, but it could be deadly. Horrific accidents were all too common. These engines collided at dawn, February 16, 1865, a mile east of Batavia on the Canandaigua branch. Reckless dispatching, fatigue, and liquor were among the more common causes of accidents.

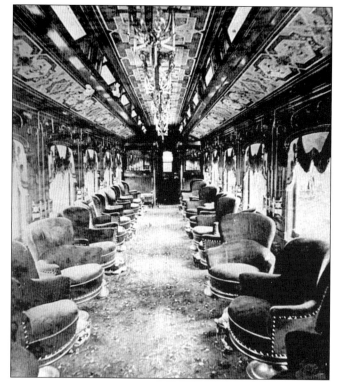

The best way to view the scenery along the Water Level Route was from the window of a Wagner or Pullman parlor car on one of the premier flyers. This Wagner-built parlor car of the 1870s featured plush—though scratchy—upholstery, mahogany inlays, brass fittings, hand-painted detailing, and carpeting. The Central ordered drawing-room cars and sleepers with individual staterooms inspired by those on riverboats.

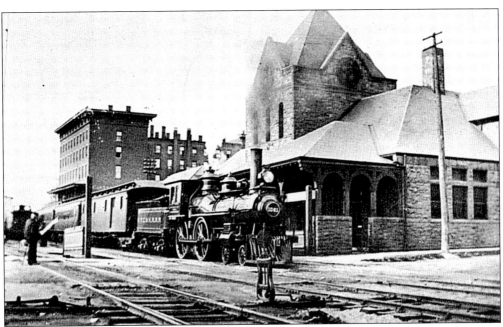

The Canandaigua station, located in the heart of New York's beautiful Finger Lakes District, was built in 1890. Local residents Mr. and Mrs. Thompson personally prevailed upon the Vanderbilts to erect the substantial stone-and-masonry station. It replaced a station and waiting room in the basement of the Canandaigua Hotel.

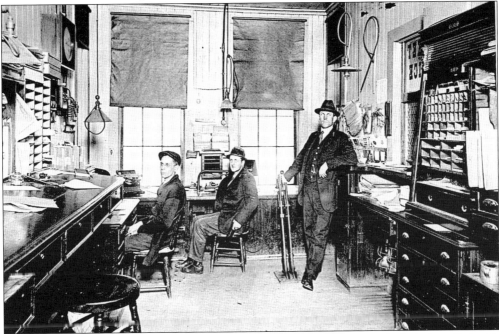

A look inside a Hojack ticket office reveals ledgers, lanterns, and a pigeonhole desk stuffed with tickets, timetables, and baggage tags. The levers the fellow on the right is holding worked the semaphore mast. The Hojack ran along Lake Ontario, connecting Oswego with the famous Suspension Bridge at Niagara Falls. (Photograph by Charles M. Knoll; courtesy NYCSHS.)

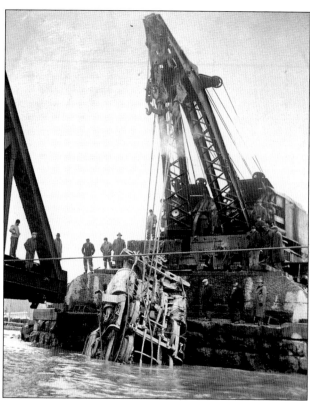

Cranes lift a locomotive out of the Genesee River, at Charlotte just north of Rochester. The locomotive plunged off the swing bridge on the left on April 20, 1947. (Courtesy Rochester Chapter NRHS.)

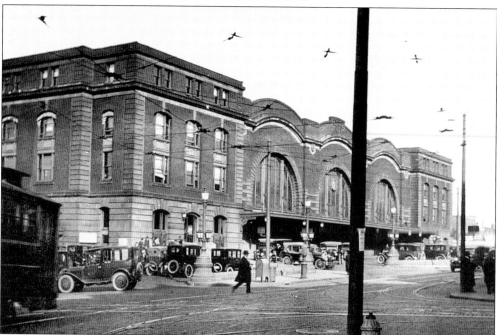

The third station at Rochester opened in 1913 and was designed by noted architect Claude Bragdon. It was considered among the railroad's most beautiful stations. The loss of this masterpiece has left a lingering wound in the city. (Courtesy Rochester Chapter NRHS.)

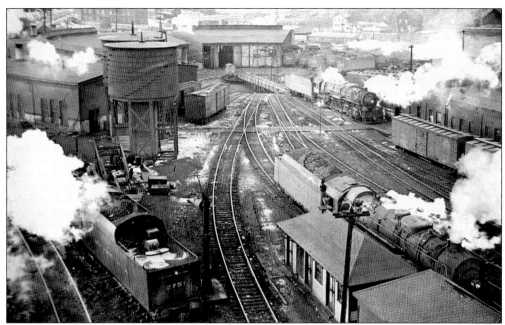

Patches of snow and billowing steam contrast with the drabness of the Atlantic Avenue roundhouse in Rochester. In nearby East Rochester, the Merchants Despatch shops manufactured many boxcars and refers for the Central. It was the twilight of steam when Wallace Bradley took this photograph in 1950. (Courtesy Rochester Chapter NRHS.)

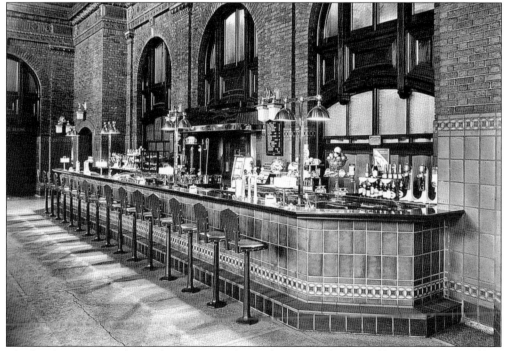

The lunch counter at the Rochester station featured ceramic tiles, a marble counter top, and lots of nickel-plated accessories. The Central often ran the restaurants in its larger stations using meat and poultry from its stockyards and farms—the same food served on their famous limiteds.

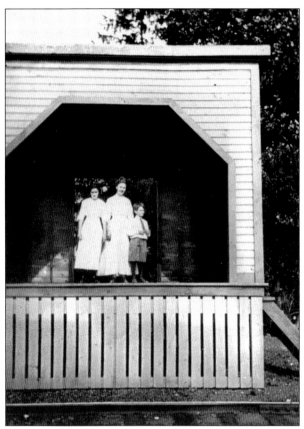

The once common "Milk Station" has long since faded from the countryside. Most dairy farmers had them. This one, located near Rochester, was unusually decorative. Note the high platform, which made rolling milk containers into the cars easier. This *c.* 1915 photograph was taken by George Corby. (Courtesy Cathy Corby Gardner.)

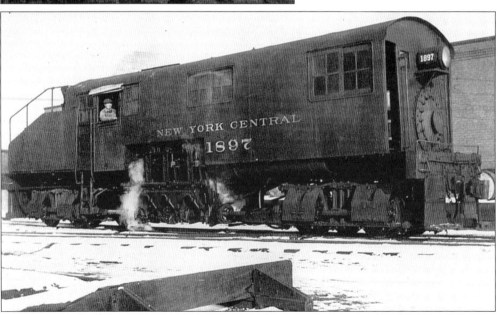

Five shays were built by Lima in 1923 for use around New York City. Replaced later with battery and combustion engines, this one was relocated to Rochester, where it worked the upper falls industrial district. (Photograph by John Woodbury; courtesy Rochester Chapter NRHS.)

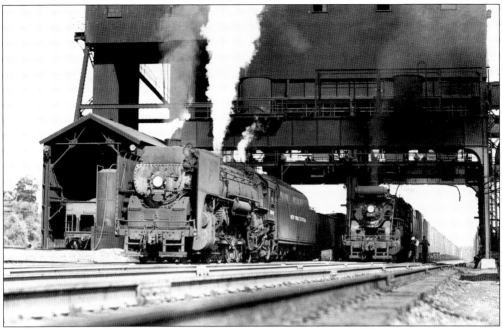

Two westbounds will be hitting the heavy iron after refueling at the Wayneport coaling station on July 3, 1948. Water troughs along the main line allowed trains to scoop water at 80 miles an hour. (Photograph by Dr. Adrian Buyse; courtesy NYCHS.)

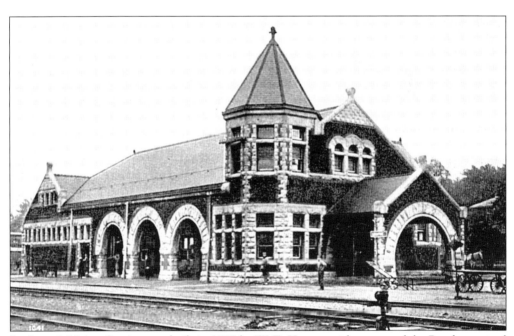

Lockport's Union Station was built in 1888 by W. E. Huston with stonework by Bendenger and Young and additional masonry by McDonaugh Brothers. Lockport is the site of the renowned double set of five locks that lifted the Erie Canal up a 60-foot rise in the Niagara Escarpment. The station is a wreck now but hopes for its revitalization remain alive.

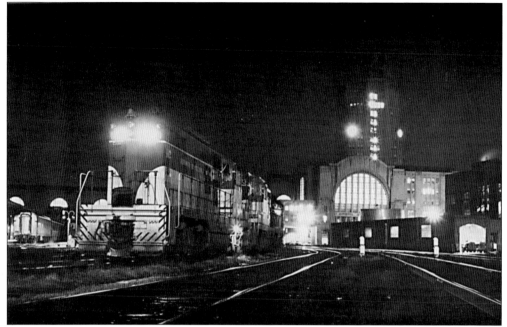

A 1950s nighttime photograph of Buffalo Central Terminal, taken by Allen A. Jorgensen, finds a passenger train using Toronto, Hamilton and Buffalo Railroad geeps. The Central purchased this railroad jointly with Canadian Pacific Railway in 1895. Among the more famous Central passenger trains to use this station were the Empire State Express, New England States, Detroiter, Commodore Vanderbilt, and Pacemaker. (Courtesy Rochester Chapter NRHS.)

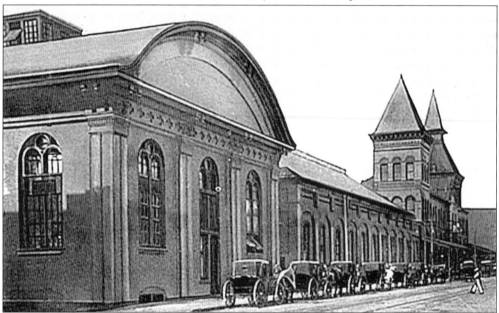

Buffalo's first true railroad station is depicted in this postcard. It was built by the New York Central and Hudson River Railroad on Exchange Street in 1848. A site for a union station to receive most regional trains was chosen but never developed. This station, enlarged five times, served until the 1920s.

Buffalo's Central Terminal opened in 1929, and by midnight of the first day it was receiving 200 trains. The 17-story art deco showplace would yield to the super highway, airplanes, and busses. Long-haul trucking chipped away at its freight business. Ironically, the government subsidized the competition with railroad dollars. The Central Terminal Restoration Corporation is now lovingly tending the old grand dame.

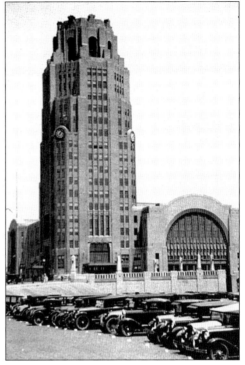

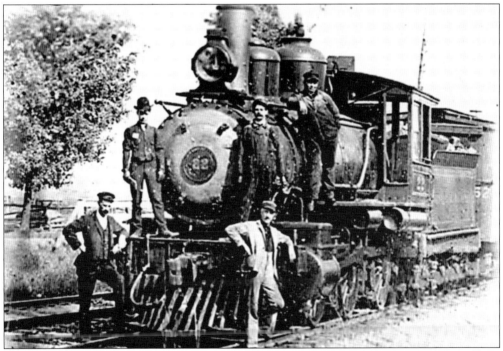

The crew of locomotive No. 22 of the Toronto, Hamilton and Buffalo Railway pose proudly in this *c.* 1910 portrait. Oddly, trackage was never built into Toronto or Buffalo. Parent company tracks were used, instead, for those destinations. Service of the Niagara Peninsula and Ontario began in 1892. In 1977, the Central—then Conrail—sold its shares to the Canadian Pacific.

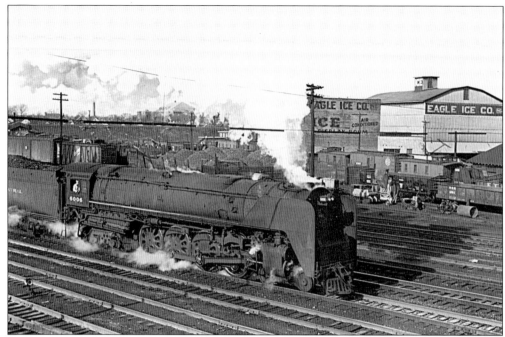

Sporting smoke deflectors (elephant ears), Niagara No. 6006 grumbles alongside Buffalo's Bailey Avenue on February 12, 1950. Evenly coated with grime, it is nearing the end of its days. A hybrid incorporating features of the Hudson and Mohawk, the Central ordered 27 of these magnificent locomotives starting in 1931. They were dual use, often heading up assignments of the Great Steel Fleet along the Water Level Route. (Photograph by Joseph Brauner; courtesy NYCSHS.)

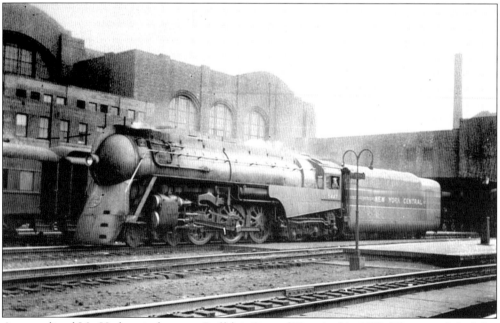

A streamlined J-3a Hudson is shown at Buffalo's Central Terminal in 1939. (Photograph by John Woodbury; courtesy Rochester Chapter NRHS.)

Three

STREAMLINERS AND DREAMLINERS

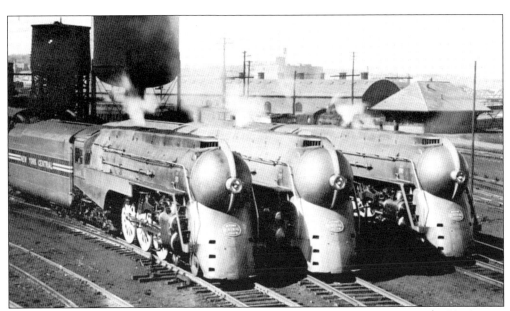

The decline of passenger service brought on by the automobile was felt even in the bleak years of the Great Depression. The trend of streamlining was launched in hopes that pizzazz, futuristic styling, and advanced technologies would lure passengers back. True rail fans of the time had mixed emotions. Some favored the old steamers with their piping and exposed mechanics. Others were immediately drawn to the stylish looks of these new lords of the rail. One thing was certain, nothing like them had ever been seen before. They were spectacular and sensational, bringing families to stations just to see them arrive and depart. The New York Central was at the forefront of the trend. These three new J-class Hudsons, recently arrived at Rensselaer, will soon be pulling the prestigious 20th Century Limited.

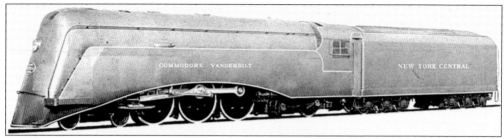

The Central's entry into streamlining was hardly timid. An eye for design, style, and art was embodied in the mysterious and bold *Commodore Vanderbilt*. Hudson No. 5344 was shrouded at the West Albany shops. It was a sensation on its inaugural run, pulling the 20th Century Limited between Chicago and Toledo.

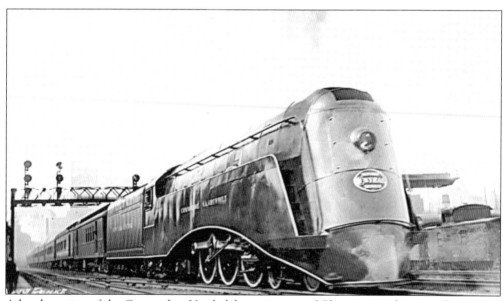

A head-on view of the *Commodore Vanderbilt* coming out of Chicago reveals more of its unique styling. Industrial artist Henry Dreyfuss did well for one of his first attempts, although repairmen did not like it. The shrouding made maintenance much more difficult, particularly on the driving rods and valves, which needed constant attention.

The public's concept of streamlining was effectively conveyed in this drawing. Of course the shrouds were not one piece, but many carefully fabricated pieces fitted together. Another worry was the added weight could further stress locomotives.

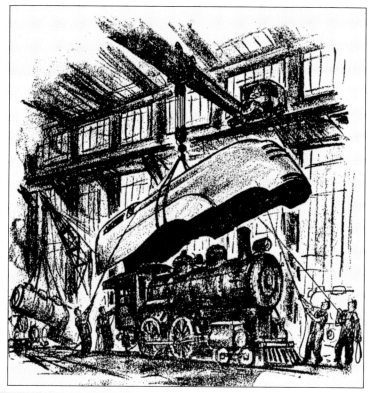

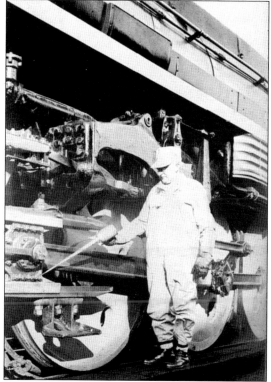

A few squirts of oil, and this streamlined Hudson is ready to roll. The photograph gives one an idea of the size of these locomotives compared to mere mortals.

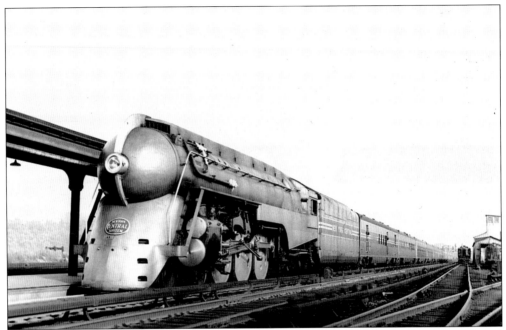

Prestige passenger trains were usually pulled by a T-motor electric on electrified track from Grand Central, along the Harlem River to Spuyten Duyvil and then to Harmon to be handed over to one of these beauties. The 20th Century Limited made crew and engine changes at Syracuse, Buffalo, and Toledo. (Courtesy Jeff Hands.)

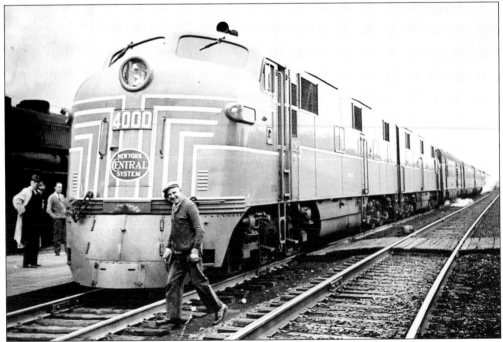

Diesel streamliners were sometimes called Dreamliners. A fellow gives a smile as he crosses the tracks in front of a glowing E-7 assigned the Water Level Limited. (Courtesy Rochester Chapter NRHS.)

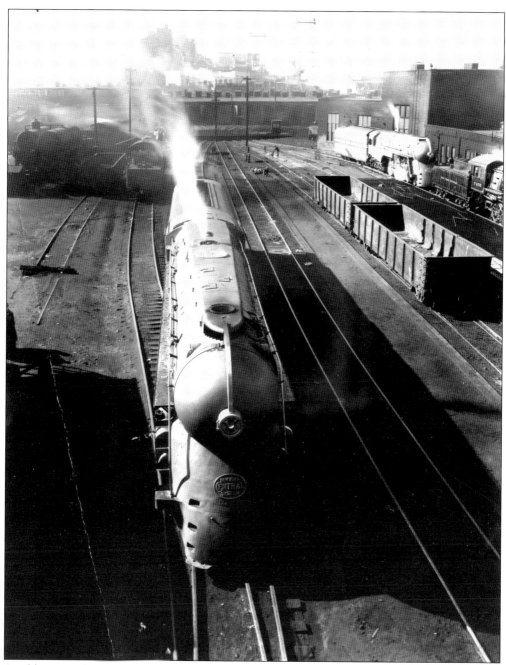

A seldom seen look at the top of a streamlined Hudson is provided with this photograph taken March 1938 in Rensselaer. (Courtesy Jeff Hands.)

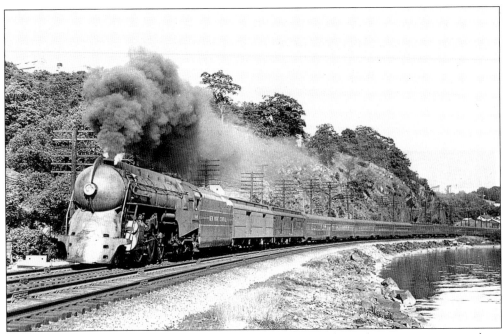

The Hudson River glistens in this June 14, 1943, photograph as the train steams north at Peekskill, 45 miles outside New York City. The impressive smoke plume suggests careless firing for the sake of the photograph. (Courtesy Jeff Hands.)

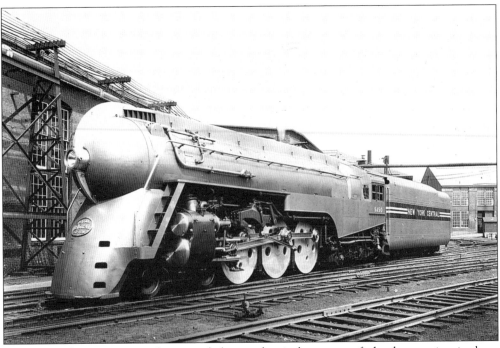

Henry Dreyfuss incorporated more of the mechanical aspects of the locomotive in later designs. This streamlined Hudson was photographed in April 1938 in Schenectady. (Courtesy Jeff Hands.)

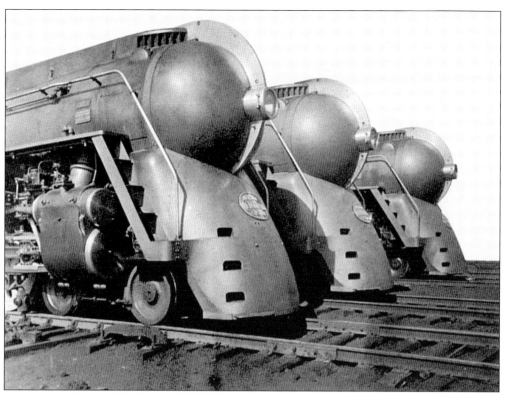

From any angle, these "bullet-nose" Hudsons were impressive.

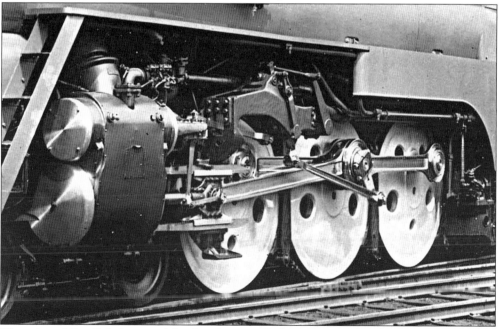

The original Box Pok drivers of the first Century Hudsons were replaced in the second fleet of five locomotives with dramatic Scullin drivers. The dive rods and other parts were polished to a high chrome-like luster, and the drivers were painted with aluminum paint.

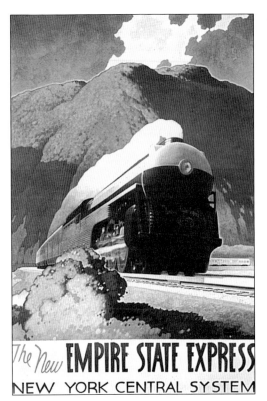

Leslie Ragan's 1940s poster of the Empire State Express is still reproduced in various sizes and sold in galleries and stores around the world. His posters elevated the appeal of industrial art to a point that they continue to be displayed in interiors by owners who have no real interest in trains.

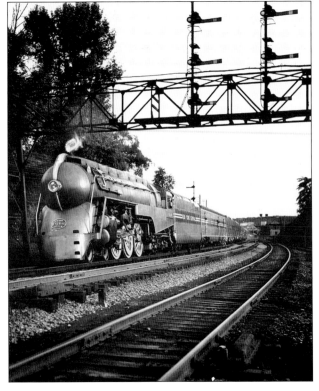

The westbound 20th Century Limited passes under a signal bridge while heading into Peekskill in August 1938. Its monochromatic paint scheme reflects the dull incandescence of approaching twilight, which is when the Century departed. (Photograph by Ed Nowak; courtesy Jeff Hands.)

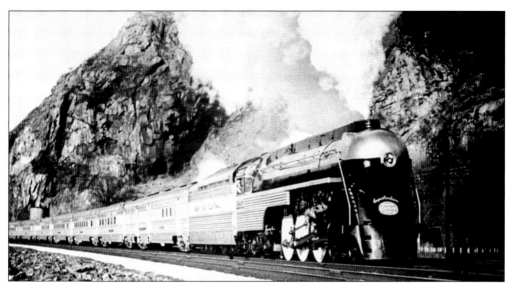

A promotional photograph catches the Empire State Express with its two-tone engine and shimmering new Budd cars high-tailing it along the Hudson River. The onetime flagship of the railroad started in 1891 when No. 999 pulled four cars from New York City to Buffalo in seven hours and six minutes. The 90-year run of the Empire State Express ended in 1971 when Amtrak took over operations.

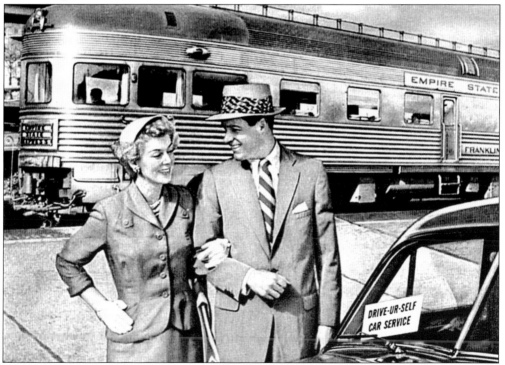

Having just enjoyed "The comfort of conditioned air in a Pullman hotel-on-wheels," on the Empire State Express, this couple will continue their journey in a "Drive-ur-self car" reserved by their ticket master. The train also offered a "Streamlined coach with deep, leanback seats. The comfort of refreshments in the lounge and a delicious meal at a dining car table."

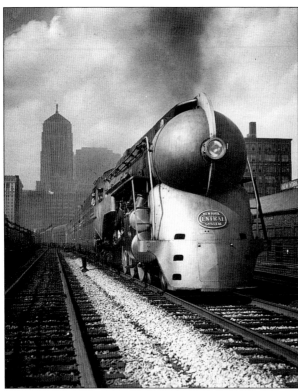

The 20th Century Limited prepares to leave Chicago's LaSalle Street Station. There was also a New York City-Boston 20th Century Limited that used the Central's subsidiary Boston and Albany. (Courtesy NYCSHS.)

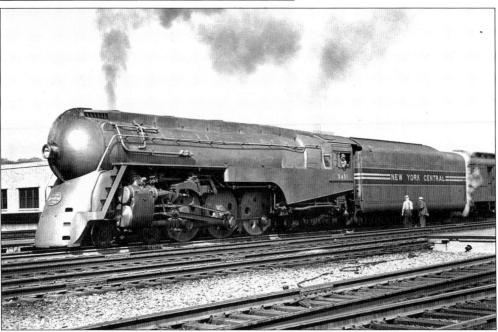

A late 1930s trackside photograph finds an engineer in the cab window consulting with two crewmen. All railroads took special pride in their new streamlined locomotives. Special scaffolds were built that could be quickly slid around the bulbous front of these Hudsons so crews could clean them. (Courtesy Jeff Hands.)

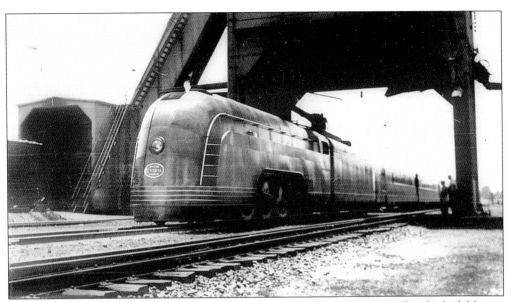

The *Mercury* was Henry Dreyfuss's first effort at streamlining. Some said it looked like an upside-down bathtub, others were spellbound by it. Dreyfuss continued to pitch his vision of the *Mercury* when Central brass was ready to abandon it. He prevailed when he said the train could be built from existing equipment.

The streamlined 20th Century Limited, depicted in this Leslie Ragan poster, became the visual hallmark for the Central for years, appearing in calendars, advertisements, timetables, promotional photographs, and brochures. The magnificent Dreyfuss-designed train offered brief hope to a depression-weary nation unknowingly about to enter the horrors of World War II.

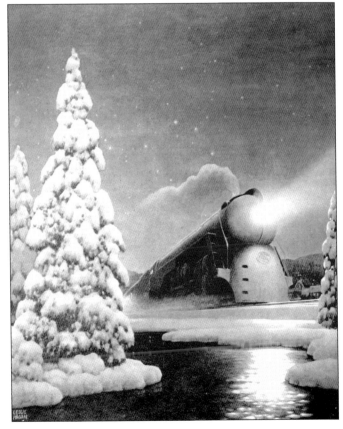

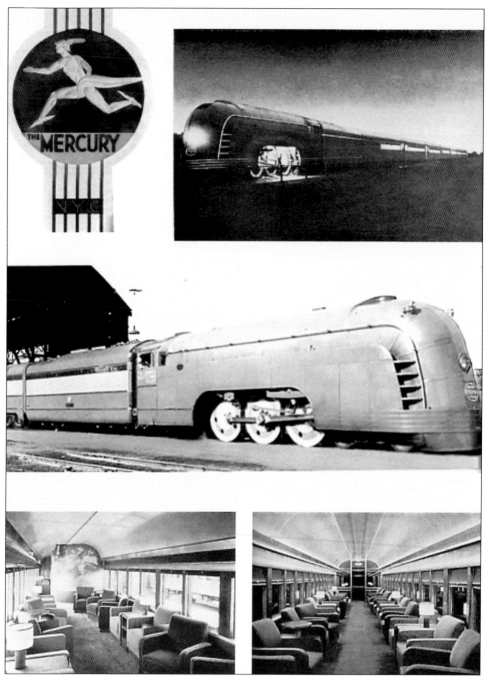

Dreyfuss customized the *Mercury* into a free-flowing work of art, from the headlight back to the drumhead. Both inside and out, every appointment from carpets, to matches, to dinnerware was incorporated into the scheme. The cars were fabricated in 1939 from surplus commuter coaches. The finished luxury coaches featured hand-painted murals on the bulkheads, sleek seating, ambient lighting, and all the latest technological advances of the day. The drivers were painted aluminum and lit at night with lights under the shroud. This dramatic touch brought rail fans out to glimpse this fleet "Train of Tomorrow" speeding through the darkness.

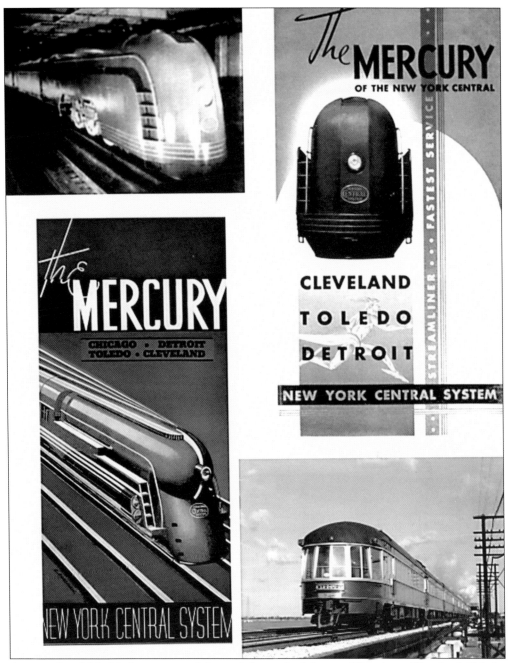

A streamlined J-3a Hudson was used for a while on the *Mercury*. The classy Cleveland, Toledo, Detroit speedster was a trendsetter with its straightforward, no frills styling. The parlor-observation car photographed by Ed Nowak (lower right) was certainly distinct.

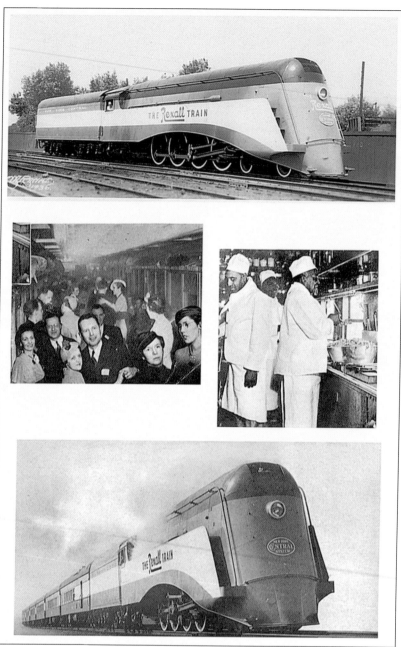

The Central used a mammoth oil-burning Mohawk to power the custom Rexall Train. Sponsored by the drug company, the all Pullman 12-car train was painted in vivid blues and off-white with dramatic Rexall Train graphics emblazoned across the engine. Intended as a convention train for employees, the public insisted on access after all its publicity. Two large dynamos powered the 21 display motors, air conditioning, and 3,000 light bulbs. Hand-picked porters could expect $100 a week in tips plus six month's wages. Two lecture cars were turned into a nightclub, and guests danced to the Rexall Train Orchestra. Three top chefs offered four-star restaurant quality meals. The train traveled nearly 30,000 miles in 1936, visiting 144 cities in 47 states and being visited by 2.3 million people.

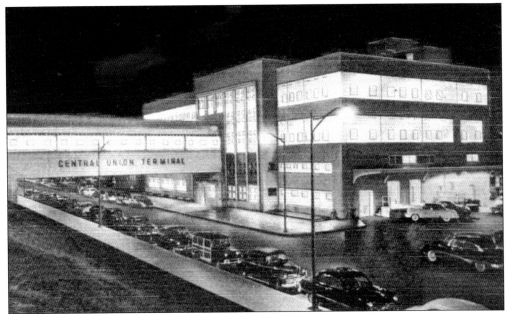

Toledo's new station received streamliners in class. The postcard boasts, "The interior beauty of Toledo's new multi-million dollar Union Station stems from the very simplicity of its trim lines of warm gray brick and limestone, great areas of glass block and picture windows. With its bold colors, stainless steel and aluminum trim and recessed lighting, the interior is designed to serve the railroad passenger efficiently, comfortably and safely in a warm and cheery atmosphere."

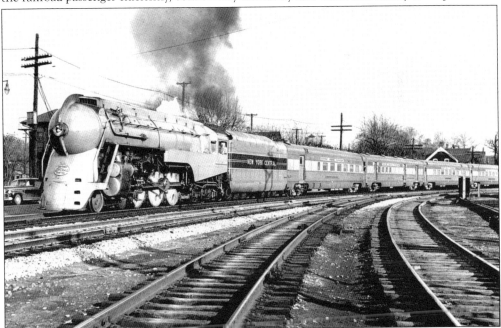

A class J-3a Hudson is handling the new Empire State Express at Elkhart, Indiana. Two designated Empire streamlined engines were nearing completion when this photograph was taken in the fall of 1941. This Hudson had no trouble with the new streamlined steel cars. (Photograph by Robert C. Schell Jr., Robert G. Spaugh collection; courtesy NYCSHS.)

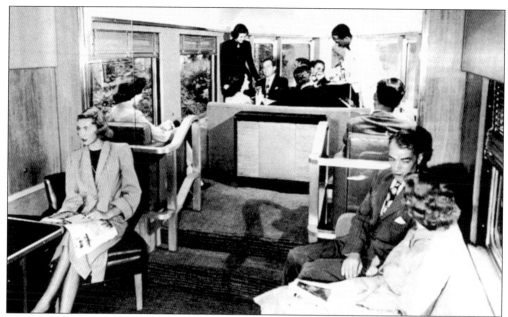

The revolutionary design of the Dreyfuss 1937 Century captured the world's imagination and set a standard rarely duplicated. The view offered by the solarium-styled observation was much desired. A speedometer on the wall appraised passengers of the train's speed. The train offered magazines, classical and popular music piped in from RCA, stationary, a valet, maid service, a barber, hairdresser, bar service, and newspapers.

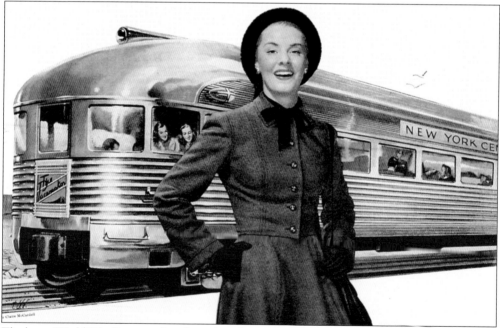

The boost World War II gave railroads produced a postwar prosperity that was devastating for them in the following decades. This idealized advertisement, touting Pacemaker service, attempted to increase passenger business with reduced rates (and services). A Pacemaker freight service picked up (LTC) less than carload freight with its own trucks and brought it to and from stations.

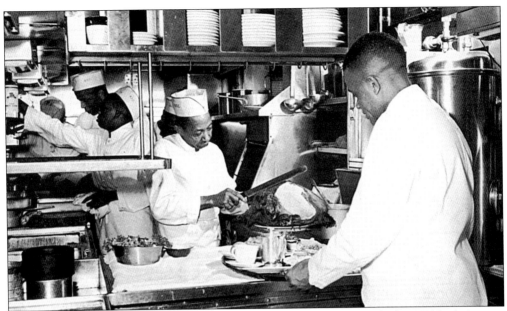

The meals prepared at the efficient stainless-steel kitchens rivaled the Waldorf Astoria. Passengers checked off what they wanted on the menu order slip and gave it to the waiter. The Century left at dusk, so dinner was primary. After dinner, the white linens were removed and rust-colored fabrics were put out. Subdued lighting came on, music was piped in, and the dinning cars became art deco nightclubs. (Courtesy Rochester Chapter NRHS.)

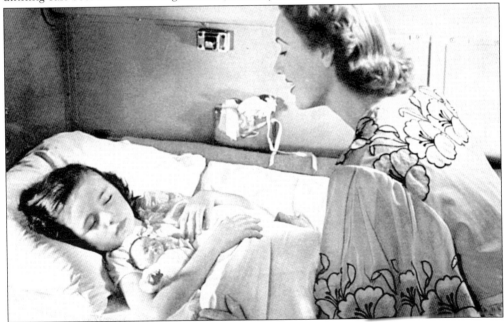

A mother sends her daughter toward slumber time aboard a dreamliner. The advertisement was reassuring; the sleeper "Glides behind clean, smooth, diesel-electric power," which also provided a "comfortable, dependable, all-weather hotel-on-wheels. Completely appointed rooms with deep, soft beds. A refreshment lounge for sociability. Famous meals . . . fresh from a stainless steel kitchen, enjoyed at leisure at your dining car table."

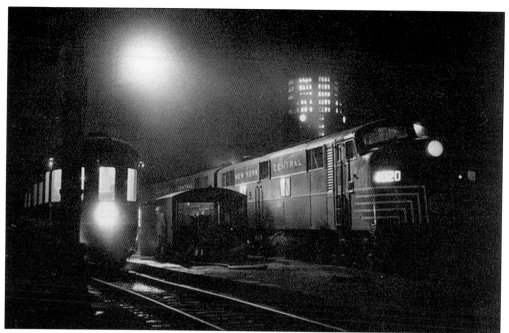

Buffalo's Central Terminal is somber in the early morning hours. The Ohio State Limited is ready to depart. To its left is the illuminated observation of a westbound Century that has stopped for brief servicing. The Century consist was primarily Pullman sleepers with private roomettes, diners, and lounges. The roomettes offered various lighting schemes for sleeping and reading.

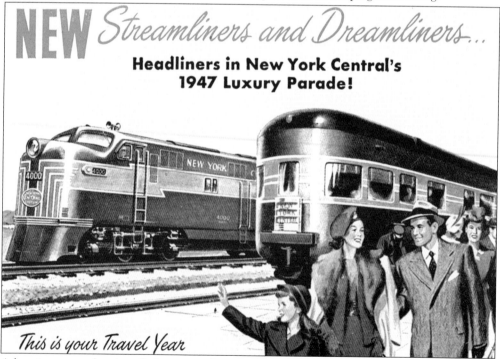

Advertisements showing flashy streamliners with bold lightning bolt graphics hoped to attract families.

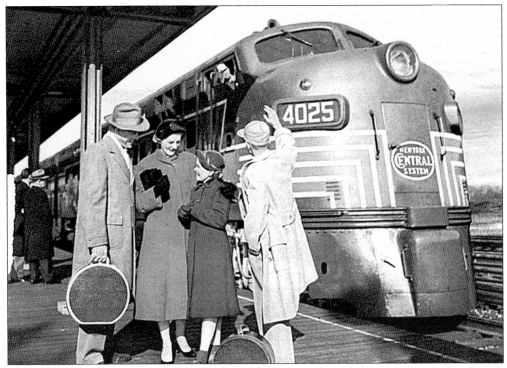

The engineer of a streamliner in lightning livery gives a wave to a son standing with his family on a station platform. In this 1950s advertisement, potential travelers were told, "You'll enjoy and learn a lot from the beauty and history that parades past your picture windows. Those close-ups of the scenic Water Level Route hold your youngsters quietly fascinated, mile after mile."

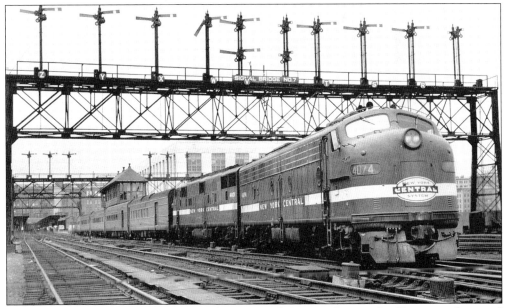

"The New England States" train No. 27 departs South Station, Boston, for Chicago under signal bridge No. 7. The EMD (Electro-Motive Diesel) 8 and EMD 7 locomotives have limited graphics. This July 3, 1965, photograph was taken by Dr. Louis A. Marre. (Courtesy NYCSHS.)

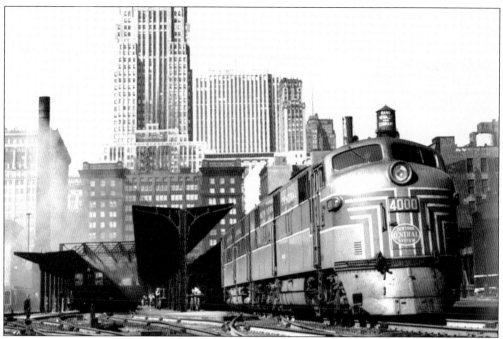

The later diesel version of the 20th Century Limited glides out of Chicago's LaSalle Street Station. Although the locomotive did not convey the romance of the earlier steam era, the train remained impeccable, exclusive, and an exhilarating "must-ride" for America's social elite. Presidents, millionaires, and stars from Garbo to Sinatra, as well as famous authors and artists, rode the luxury liner. (Courtesy NYCSHS.)

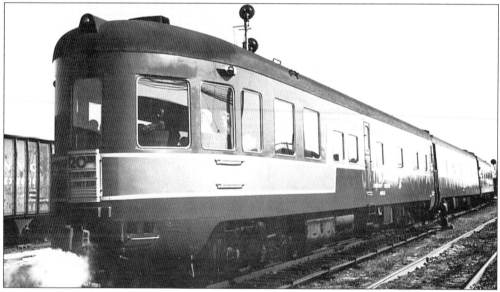

Drab green, multi-riveted heavyweights yielded to the luxurious streamlined Pullman "Creek" cars of the late 1930s. The monochromatic paint scheme of grays, silver stripes, and blue edging spoke of futuristic things. Passengers aboard the 20th Century Limited train No. 26 peek from the observation Hickory Creek while stopped at Englewood, Illinois, to pick up passengers. (Photograph by Walter A. Peters; courtesy NYCSHS.)

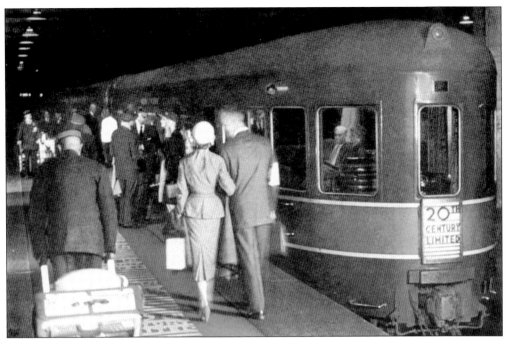

A couple is directed down the red carpet to their car by a "redcap," station attendants with bright red bands around their hats. Passengers were led past the illuminated destination signs where conductors in dark suits and with pocket watches handled tickets. Porters stood at the vestibule of each Pullman sleeper to welcome passengers to their roomettes. From start to finish the 20th Century Limited experience was exhilarating and memorable.

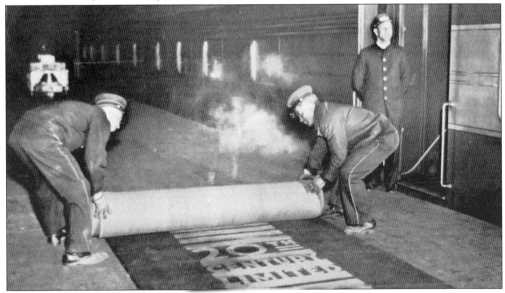

Everything about the 20th Century Limited, from conception to execution, had the mark of brilliance to it. The burlesque tradition of rolling out a red carpet, bearing the Dreyfuss Century logo, is said to have come from the train's originator, George C. Daniel, having seen servants roll out red carpets for the Vanderbilts upon returning to their mansions. (Courtesy Rochester Chapter NRHS.)

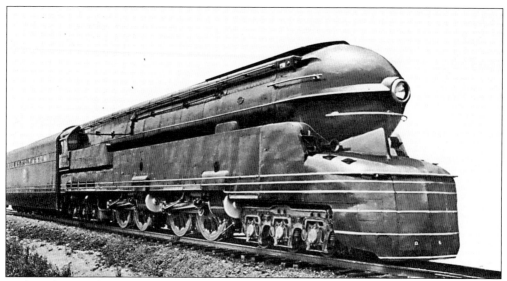

Archrival Pennsylvania Railroad's Broadway Limited was considered every bit as fashionable as the 20th Century Limited. They commissioned noted industrial artist Raymond Loewy to outfit their luxury train. Often the two rival trains pulled astride while entering Chicago. The passengers and crew would wave. Loewy's radical one million-pound class S1 was a stunner.

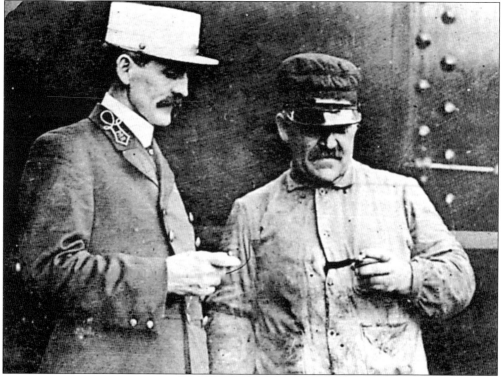

Conductor and engineer coordinate pocket watches, as was the tradition. Their proud railroad, the Pennsylvania, would merge with the Central in the late 1960s. Employees supplied their own timepieces, at least 17 jewels, which were inspected by the railroad. No covers were allowed as they might stick shut. Families saved to buy dad the best "railroad standard" watch they could.

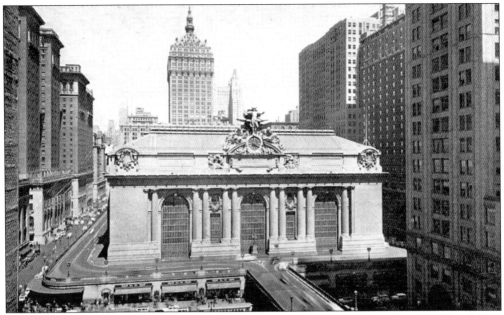

The 20th Century Limited and Broadway Limited ventured in and out of remarkable edifices. Grand Central was designed as a majestic Beaux-Arts showplace. Three 60-foot windows along the facade are flanked with Doric columns. Statuary abounds, particularly the mythological figures of Mercury, Hercules, and Minerva over the center window. A viaduct transports Park Avenue traffic around the terminal.

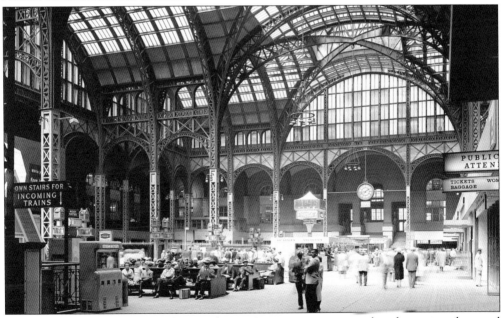

Pennsy's Broadway Limited used Pennsylvania Station, a monumental pink granite, glass, and iron masterwork by McKim, Mead, and White. The railroad tunneled under the Hudson to reach the New York market. The aboveground portions of the station were demolished in a wrathful act that shook the architectural community. This April 24, 1962, photograph was taken by Cervin Robinson for HABS (Historic American Building Survey).

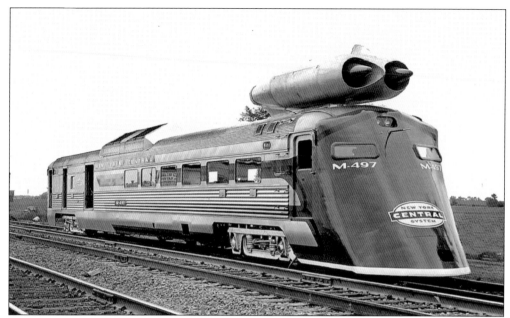

The futuristic "Black Beetle," introduced in 1966, was a 13-year-old RDC-3 car fitted with two turbo-jet aircraft engines and a streamlined front. A sad attempt to compete with airlines, it was also intended to counter bad press after the Central discontinued the 20th Century Limited, Wolverine, and Empire State Express. Claims of 183 miles per hour in an Ohio test run meant little, and the car was put back in service stripped of embellishments.

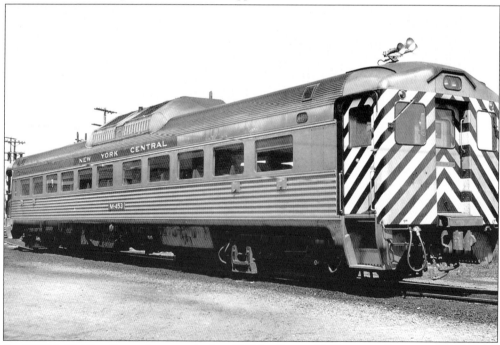

An RDC-1 "Beeliner" was photographed in 1963 by George E. Votava at Brewster. This was an 85-foot-long, self-propelled, diesel-hydraulic passenger car powered by two bus engines. They were used mainly for rural commuter service. (Courtesy NYCSHS.)

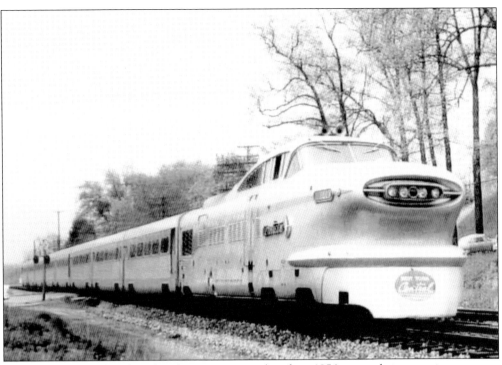

The Aero Train (above) and Xplorer were introduced in 1956 to spark interest in passenger service. The Xplorer promoted speed, a striking modern interior, and a smooth ride on a new air-cushion suspension system. The ride was actually quite harsh, and the locomotive was plagued with problems. Both trains were dropped a year later. The Xplorer photograph, from the collection of Dr. Louis A. Marre, was photographed on the Big Four, running between Cleveland and Cincinnati. (Courtesy NYCSHS.)

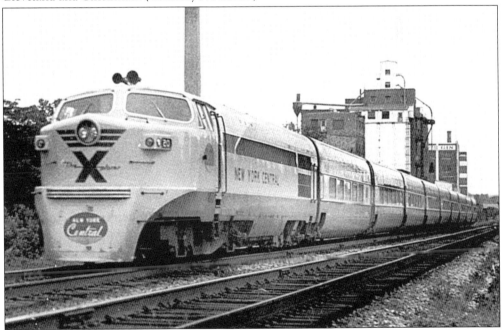

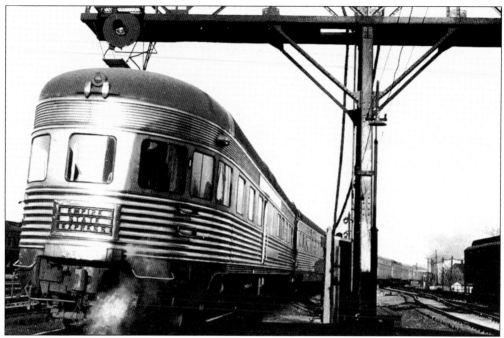

The fluted steel tavern-lounge observation of the Empire State Express shimmers after leaving the shadows of the Rochester station platforms sometime in the mid-1940s.

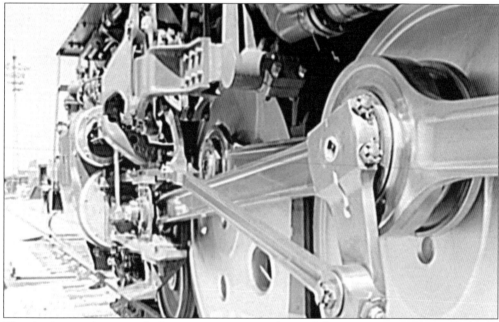

The driving mechanism of a locomotive is a complex and fascinating assemblage of wheels, rods, brakes, compressors, and cylinders. The problem of "quartering" wheels so they moved in unison always challenged designers. This streamlined Hudson at the 1939 word's fair represented a high point in design and function. The rods have been polished to a chromelike finish, and the drive wheels are painted aluminum. (Photograph by Gottscho-Shleisner, Inc.; courtesy Library of Congress.)

Four

THE SYSTEM

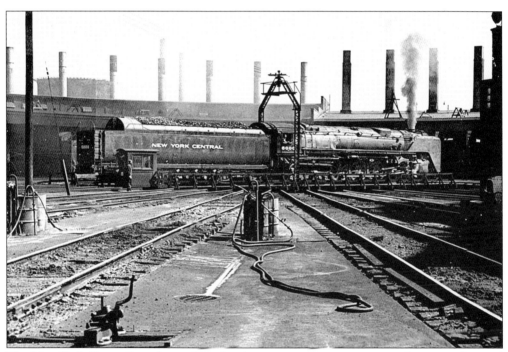

The New York Central's evolution from hay-burning steamers running on thin stone-fastened iron straps to one million–pound behemoths pounding the high iron at 85 miles an hour parallels America's emergence from a timid agricultural nation to a world industrial and military superpower. Whether hauling presidents, pig iron, cheese, immigrants, or army tanks, the Central took its role in the country's development seriously. This chapter will travel a vast and complex system of small and major railroads that comprised the New York Central System. Pictured above, a Niagara revolves on the Collinwood, Ohio, turntable. The tender could hold 43 tons of coal. (Photograph by Onerio L. Sabetto; courtesy NYCSHS.)

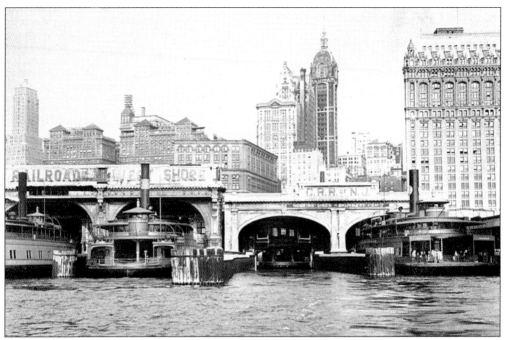

The system had a marine department that included the West Shore Ferry with fleets of tugboats, ferries, car floats, barges, and other vessels. This 1939 view shows the Cortland and Liberty Streets ferry terminals and slips in Lower Manhattan. Tickets in and out of New York City included ferry passage across the Hudson. (Courtesy Library of Congress.)

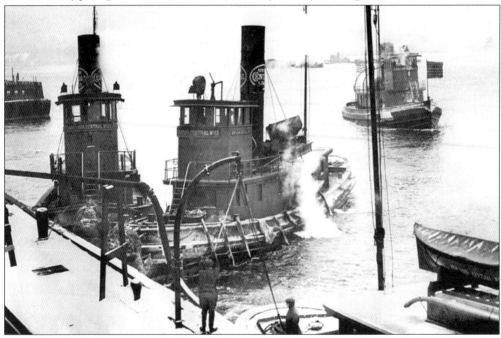

Three New York Central tugs operate on the Hudson during a cold January day in 1927. The one out on the river, No. 37, was a new diesel electric and the most powerful tugboat in the world. (Courtesy NYCSHS.)

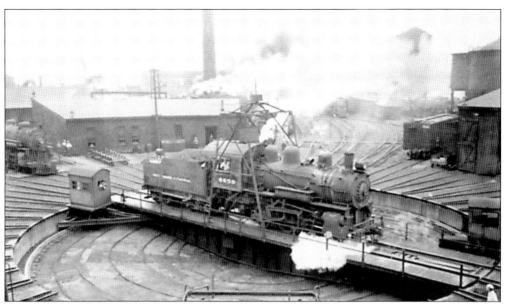

A rugged switcher is photographed on a turntable in Rochester in the early 1950s during the twilight of steam power. (Courtesy Rochester Chapter NRHS.)

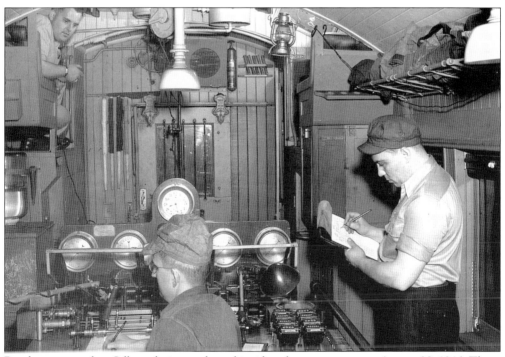

Road tests on a class S-lb are being evaluated inside a dynamometer car, August 28, 1946. These specially built cars contained equipment used to test the performance of new motive power. It was dynamometer cars that showed diesels were vastly more efficient than steam engines. Many steamers were 50 percent efficient, with half their power shooting out their smokestacks. (Courtesy NYCSHS.)

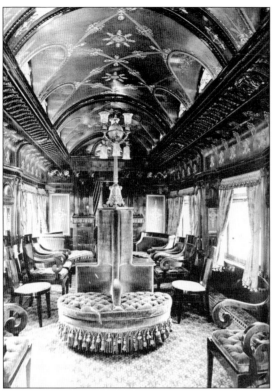

Rail barons and other social elite had private cars built. Materials included Tiffany or Pike's stained glass, gold leafing, carved mahogany, electric lights, steam heat, green and gold frescoes, and tooled leather. The Central had a small substation under the Waldorf Astoria to receive these wheeled palaces. Pictured is the Isabella built by Pullman to attract wealthy customers.

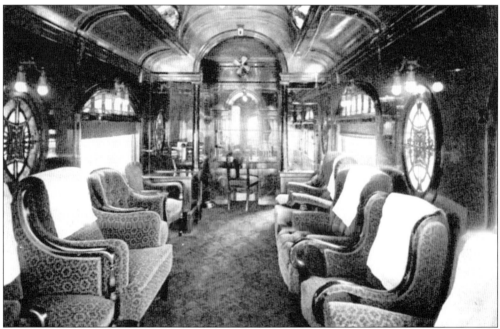

A Pullman car used on the 20th Century Limited shows the opulence of that bygone era. The Pullman Company, 1867–1969, defined luxury passenger travel in America. By the end of the 1920s it operated 9,800 cars staffed by 10,500 porters, maids, and attendants and transported as many as 30 million passengers a year.

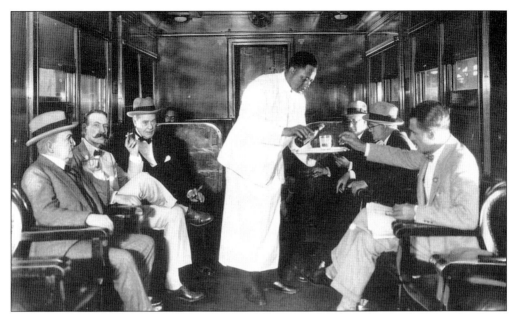

A porter serves drinks on a Pullman-operated lounge car. When George Pullman developed his palace car after the Civil War, he staffed them with freed house slaves. They were excellent butlers, porters, valets chambermaids, and babysitters. Later they would do everything from serving up Delmonico steaks to stitching up gentleman's cuffs. Their formation of a porters union was one of the first civil rights actions in America. (Courtesy NYCSHS.)

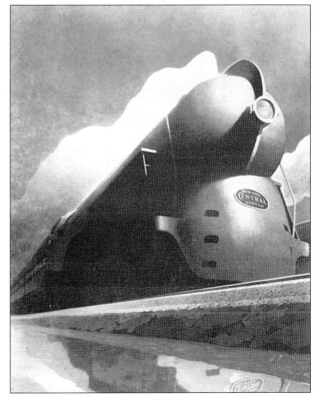

Leslie Ragan's bold rendering remains one of the railroad's most recognized images. Muscular and defiant, it symbolized an America ready to surge ahead after World War II. Most railroads had streamlined engines, some quite beautiful, but the Central's had that little something extra. In other words, they got it just right. Most of the shrouding was removed from them by the late 1940s.

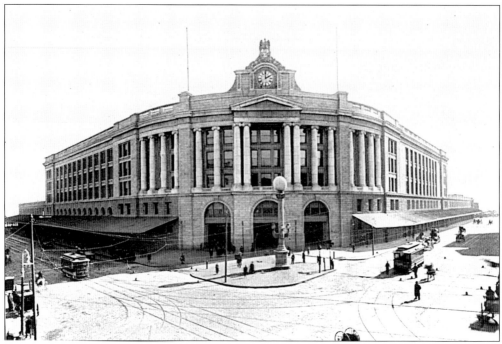

Boston's South Station, with its 16 polished granite columns, 14-foot clock, and 8-foot eagle, was the largest in the world when it opened in 1898. It handled 38 million passengers in 1916 for subsidiary Boston and Albany and the New Haven Railroad. Restored in 1989, it serves as the northern terminus of Amtrak's Northern Corridor. The Lake Shore Limited and an overnight to Chicago run from here.

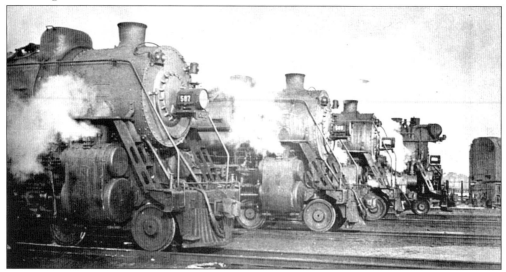

Four Boston and Albany locomotives take a breather. New Englander's were angered by the Central's 1880 acquisition of their proud railroad. They were further enraged when William Vanderbilt, indifferent to public sentiment, had Boston and Albany removed from all equipment and replaced with New York Central and Hudson River Railroad. He reversed it after criticism in the newspapers and hired a public relations firm to improve the Central's image. The Boston and Albany was then given autonomy. (Courtesy NYCSHS.)

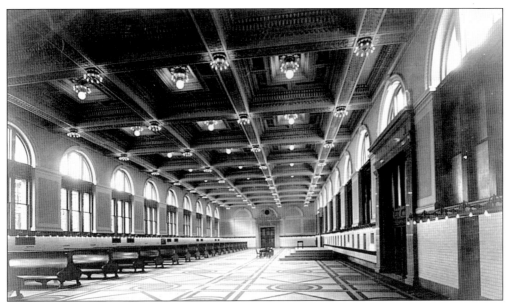

South Street Station's waiting room measured 65 feet by 225 feet and was lit by 1,200 bulbs. There was a restaurant, a barbershop, and a ladies lounge with cribs and trained nursemaids. Handsome deep green Pacifics brought limiteds to the station's 28 platforms, and the red carpet theatrics of the exclusive 20th Century Limited were performed. The station barely escaped demolition in the 1970s.

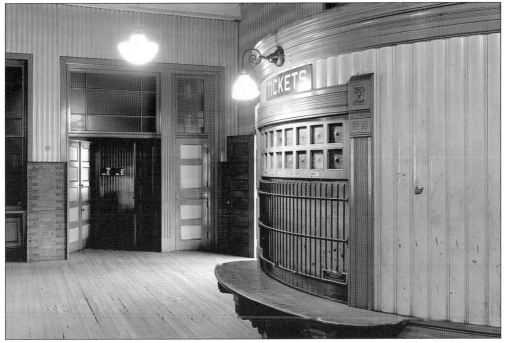

Noted architect Henry Hobson Richardson designed several stations for the Boston and Albany. This medium-sized station in Palmer, Massachusetts, was built in 1882. The wainscoting, bay ticket window, and hanging lamps in the waiting room capture the essence of the old time station. This photograph was taken by Cervin Robinson in 1959 for HABS.

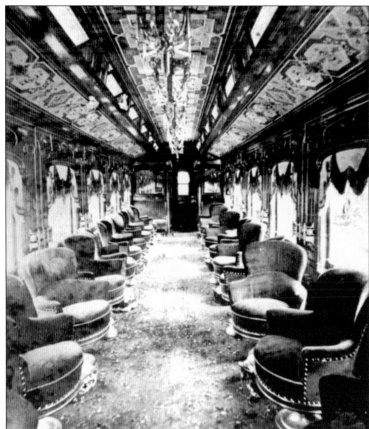

The Wagner Palace Car Company grew from the Commodore Vanderbilt–backed New York Central Sleeping Car Company. It was noted for bringing comfort to long distance passengers. Its sleepers were equipped with insulation (sometimes cork) to deaden sound, advanced suspension systems, and the Westinghouse air brake system invented in 1868. The company was bought by rival Pullman in 1900.

Many shops were used to manufacture equipment. The Alco shop in Schenectady was a primary supplier of quality locomotives. Shop workers pose beside the last steam engine to be built for the Central in 1948. (Courtesy NYCSHS.)

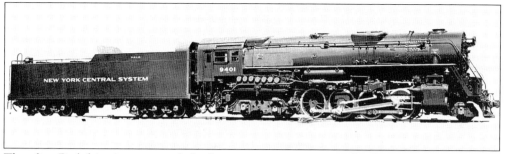

The elite Berkshire incorporated the latest in steam engine technology. Introduced during the dawn of the diesel, they had a limited reign. While pounding through the Massachusetts mountains or hills of Pennsylvania, they could burn 10,000 pounds of coal an hour. This Alco-built Berkshire served admirably on the Pittsburgh and Lake Erie.

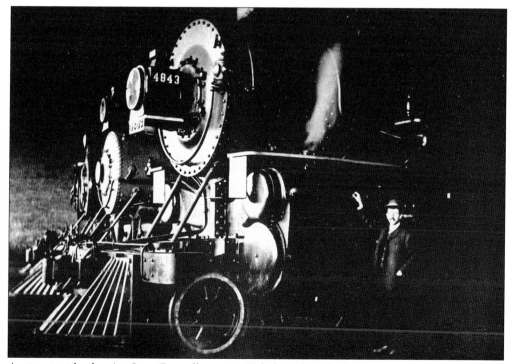

A view inside the Air Line Roundhouse in Toledo, Ohio, finds steam gently venting—soon its fire will be increased. The opening of valves will circulate hot water through its veins, and cylinders and compressors will pulse like heartbeats. A pull on the throttle will bring this marvel of engineering to life. (Courtesy NYCSHS; Bob Lorenz collection.)

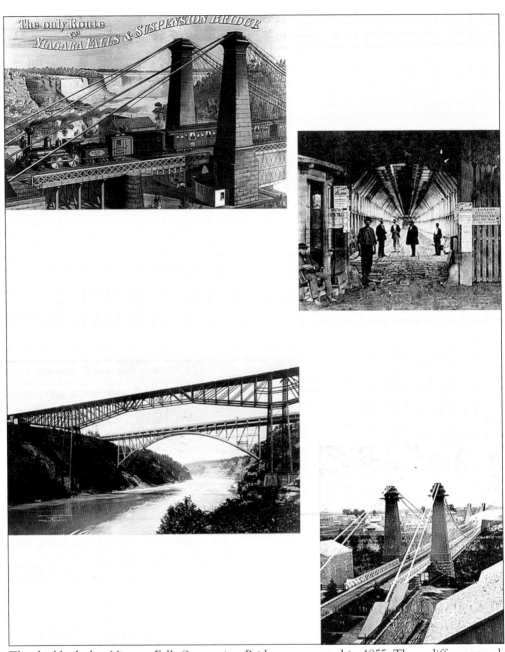

The double-decker Niagara Falls Suspension Bridge was erected in 1855. Three different track gauges fed into it. The scenic region was vital to the Central. The upper right photograph shows the pedestrian walkway under the railroad tracks. William Vanderbilt had the Niagara Cantilever Bridge (lower left) constructed for his Michigan Central Railroad and Canada Southern Railway. The double-track bridge opened in 1883. It was 906 feet long and approximately 200 feet above the river.

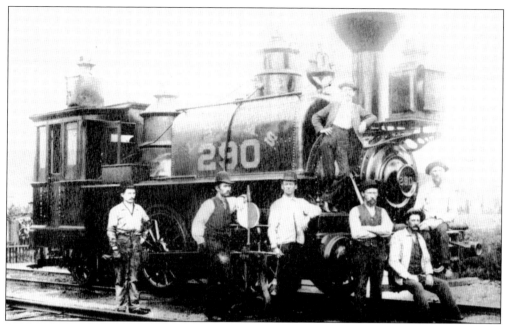

A crew poses with Michigan Southern No. 290. By 1877, the Vanderbilts had gained a majority of stock of the then Lake Shore and Michigan Southern. It extended his New York Central and Hudson River Railroad main line from Buffalo westward to Chicago with tracks across southern Canada to project his Canadian operations.

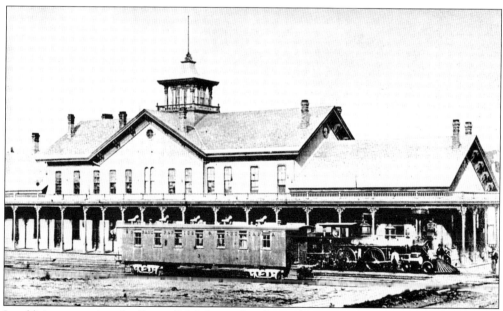

In addition to serving the Central's Michigan Southern, this station in Grand Rapids, Michigan, served the Chesapeake and Ohio and the Grand Rapids and Indiana railroads. The primitive passenger car has numerous vents. Train travel was often oppressive with noisy jostling cars usually filled with thick sooty air.

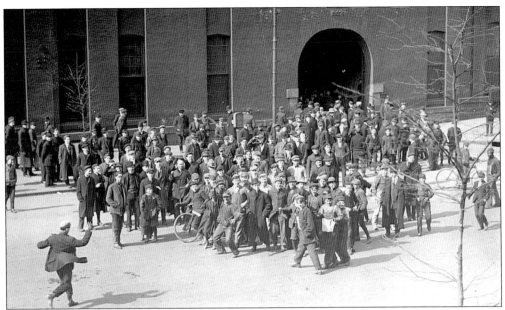

There are some youngsters among the Baldwin Locomotive Works employees in this 1910 photograph outside the Philadelphia factory. That was before child labor laws. Founded in 1831 by Matthias Baldwin, the company was in the forefront of steam engine design, building quality Mikados, Cab Forwards, and Northerns. The company merged with other builders but fell behind EMD in diesel development. (Courtesy Library of Congress.)

A riveter works on the firebox of an inverted locomotive boiler positioned in the erecting shops of a locomotive works in this photograph by Theodor Horydczak. (Courtesy Library of Congress.)

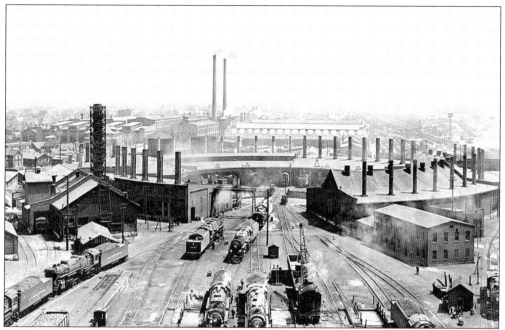

A pall of smoke and ash lingers over the Collinwood, Ohio, engine house in the 1940s. Nearby residents had to endure the endless pollution and incessant clanging of cars throughout the night as trains were made up. Few people painted their houses white because of the soot. (Courtesy NYCSHS.)

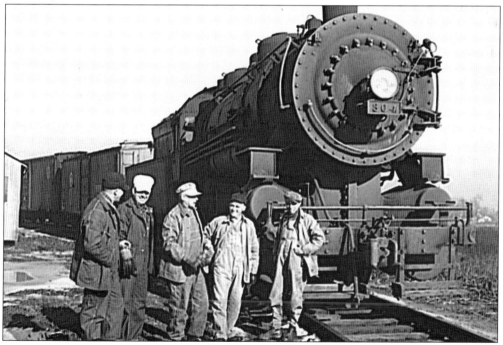

An engineer, fireman, foreman, and yard crew pose in the Central's Indiana Harbor Belt freight yard in Chicago, Illinois. This 1943 photograph was taken by Jack Delano. (Courtesy Library of Congress.)

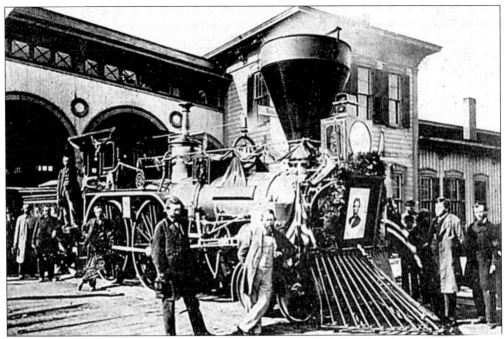

Officials and crew linger around the Nashville in 1865. Regaled in bunting, black crepe, and flags, the locomotive is preparing to pull President Lincoln's funeral train. The 4-4-0 was built 1852 in the Cuyahoga shops for the Cleveland, Columbus and Cincinnati, later called the Big Four when acquired by the Central.

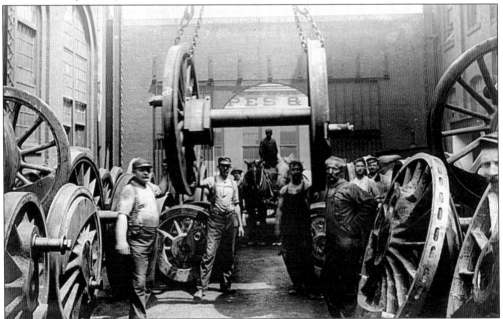

Drive wheels of various sizes are stored in the yard outside building No. 3 of an unidentified locomotive works. The Central used numerous builders—including their own shops—to turn out everything from basic switchers to mighty Niagaras. A crane is hoisting a huge set of drivers in this 1904 photograph. (Courtesy Library of Congress.)

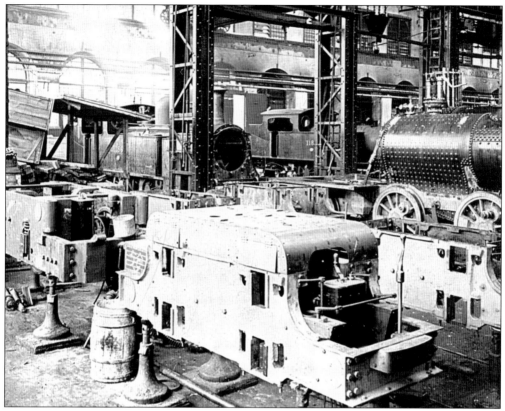

A 1905 stereographic view provides a look inside Baldwin Locomotive Works. Along with the many locomotives built for the Central, numerous Mikados and Northerns were sent to England, France, India, and Egypt. Baldwin merged with other builders after the steam age. Unsuccessful in the new diesel era, it stopped production of large locomotives in 1956.

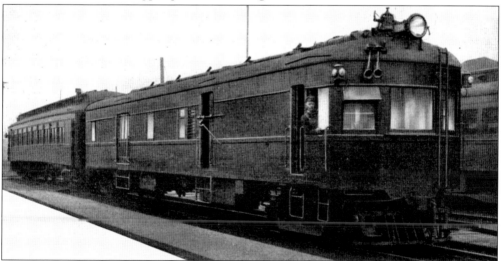

This 60-foot Brill gas-electric car was placed in service in 1926. It operated 260 miles daily on the Big Four, running passengers between Indianapolis, Indiana, and Matoon, Illinois. The Central increasingly entrusted these popular cars with broader service throughout the system.

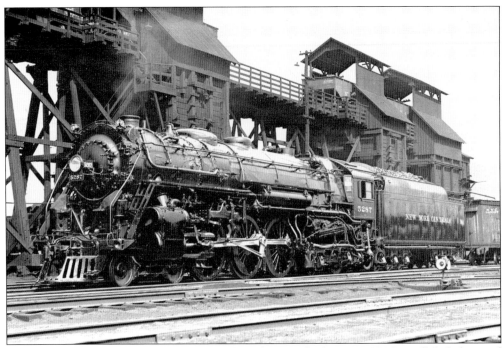

Newly built Hudson No. 5287 rolled out of the Schenectady shops in 1929. It is all fueled up and ready for service. (Courtesy NYCSHS; Vance Roth collection.)

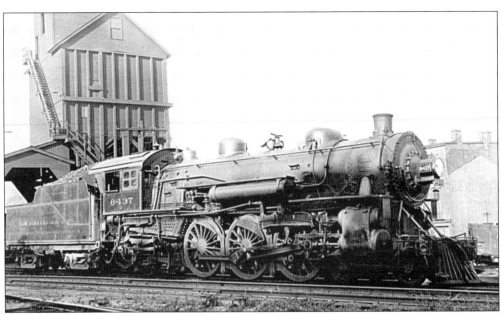

A coal tower looms behind Big Four Pacific No. 6437. Numerous small lines comprised the Big Four matrix, but in 1889, it assumed its most recognizable configuration, Cleveland, Cincinnati, Chicago, and St. Louis (CCC&St.L). Dominant in the northeast, the Big Four expanded the Central's operations into the west and southwest. A small CCC&St.L emblem was permitted, for regional pride, on the tender coal boards—over the larger New York Central System lettering.

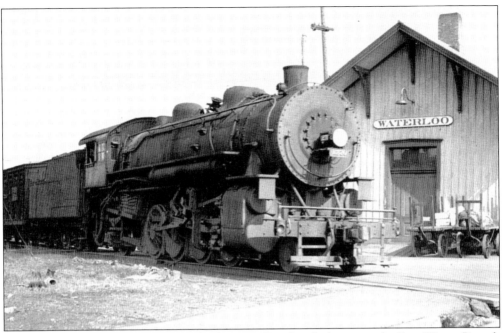

Train No. 72 pulls alongside the freight doors at Waterloo, Indiana, on the Fort Wayne Branch in March 1940. (Photograph by Philip Buchert; courtesy NYCSHS.)

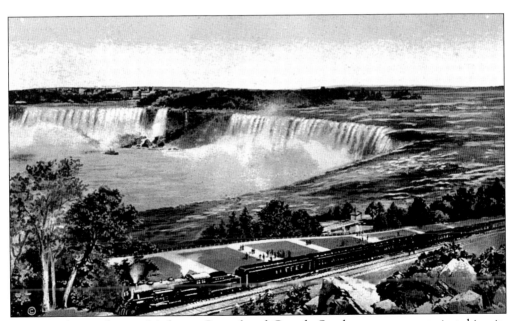

A postcard view shows a Michigan Central and Canada Southern passenger train taking its much-touted five-minute scenic stop at Niagara Falls. Note the promenades extending from the train for passengers to view the falls.

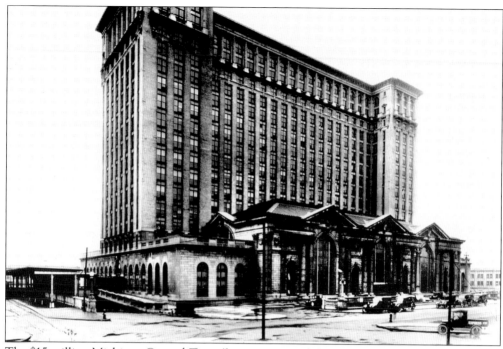

The $15 million Michigan Central Train Station, pictured during its 1913 opening, was part of a major urban project that included the Michigan Central Tunnel under the Detroit River. A classic of the Beaux-Arts style, it was prominent among Detroit's classically inspired buildings. The top two floors of the office building were never completed. Passengers arrived by interurban or streetcar.

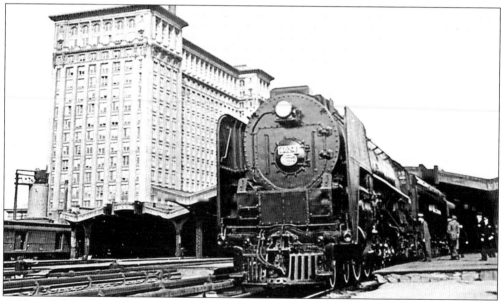

A New York Central Niagara is departing the station in a 1946 postcard photograph by Ed Nowak. The station has become a desperate ruin since the last Amtrak train pulled away on June 6, 1988. Like so many orphans of the great passenger age, it has been vandalized and stripped of its treasures. It is the subject of numerous Web sites as Detroiters seek ways to save it.

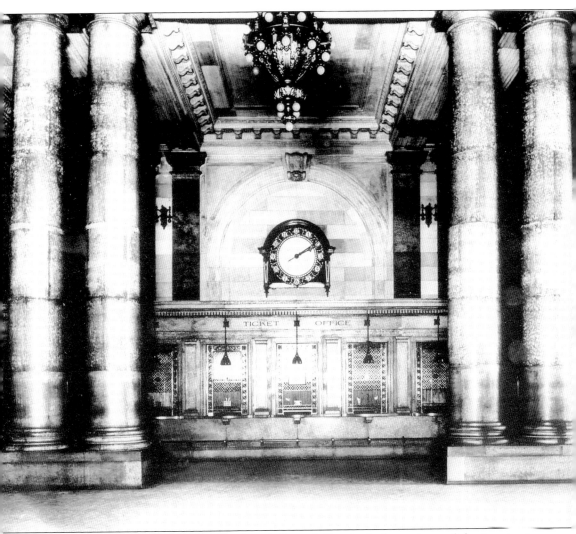

Designed by the firm responsible for Grand Central Terminal, the majesty of the interior is captured in this c. 1913 photograph. Soaring Doric columns supported the 54-foot-high ceiling of the main waiting room, and the walls were marble from floor to ceiling. There was a separate waiting area for immigrants—as was the case with most major stations of that era.

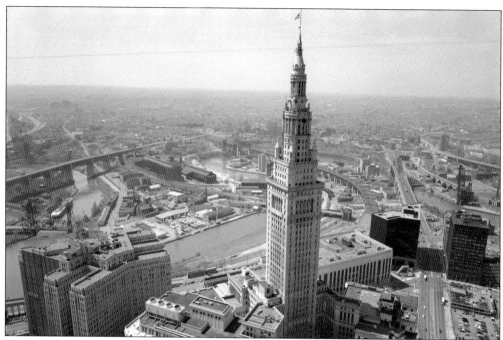

Tower City Center evolved out of the complex of interconnected buildings that comprised Cleveland Union Terminal (C.U.T.). The 52-story terminal tower was the largest skyscraper outside New York City. Over 2,200 buildings were demolished for the ambitious project. New York Central and its Big Four were stockholders along with the Nickel Plate. (Courtesy HABS.)

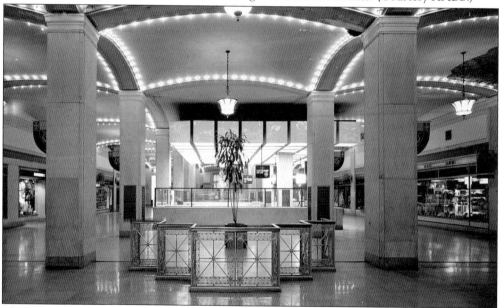

The reworked concourse in 1987 featured stores and offices. By 1990 the platforms and coach yard were demolished by the Greater Cleveland Regional Transit Authority and rapid transit tracks were put underneath the station. The concourse was converted to "The Avenue" mall and food court. Tower City represents a success in converting obsolete stations to multi-use facilities. (Courtesy HABS.)

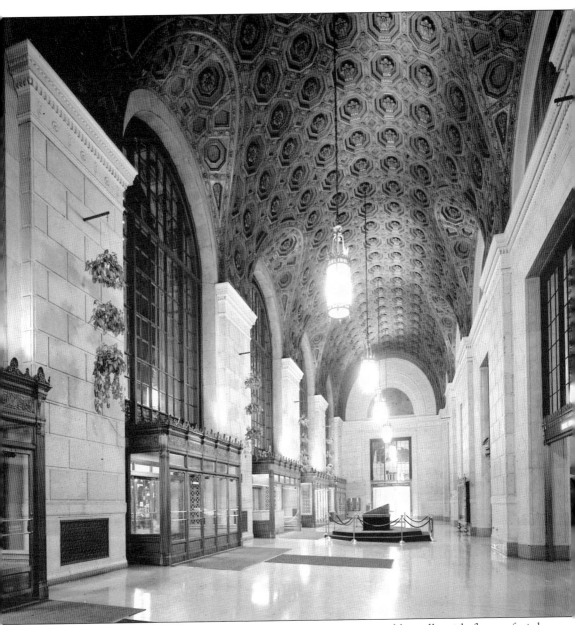

The magnificent C.U.T. concourse featured beige Botticino marble walls with floors of pink Tennessee marble. The barrel-vaulted ceiling was comprised of decorative plaster squares. The terminal complex opened in 1927 after the second-largest excavation in world history—the first being the Panama Canal. (Courtesy HABS.)

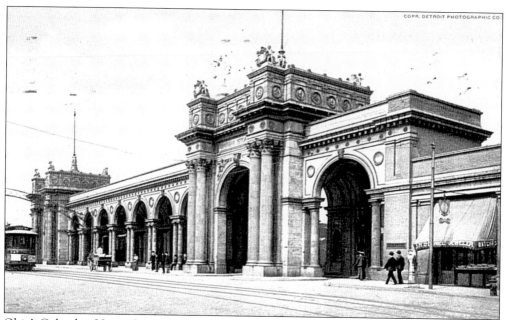

Ohio's Columbus Union Station was another Beaux-Arts beauty. Built in 1897, it included a road viaduct over the tracks to end backups that lasted up to seven hours. Daniel H. Burnham and Company drew inspiration from their designs for the 1893 Chicago's World Fair. The elaborate facade was sculptural and balanced. One of the arches survives. The station was sneakily demolished in 1976.

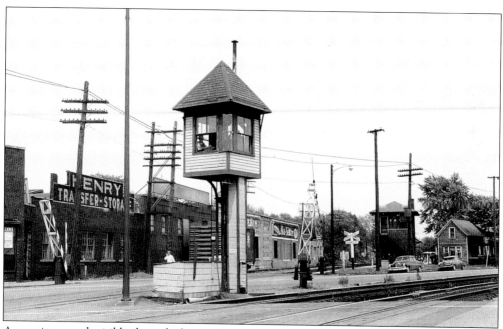

A crossing guard, visible through the window, relaxes in Tower B at the Main Street crossing at Elkhart, Indiana, in this c. 1949 photograph by Robert Schell. (Courtesy NYCSHS; Robert G. Spaugh Sr. collection.)

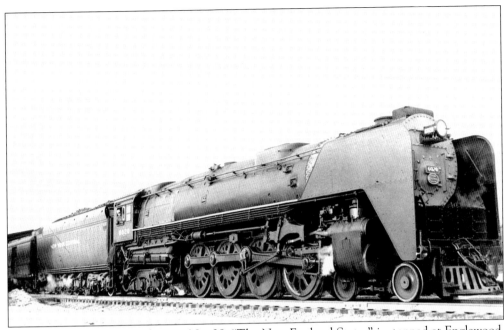

A mighty S-1b Niagara with train No. 28, "The New England States" is stopped at Englewood, Illinois, on September 16, 1948. These giants saw freight and passenger service and often headed the Great Steel Fleet. The absence of steam domes gave them a sleek look. (Courtesy NYCSHS; the late Walter A. Peters collection.)

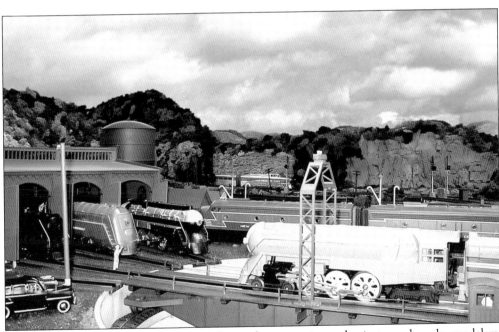

The Central remains extremely popular with toy train enthusiasts and scale modelers. Streamliners vie for a spin on the turntable of Richard Panke's layout. They have come a long way from their clockwork predecessors. These engines have realistic digital sounds and train control. Note the Aero Train in the distance.

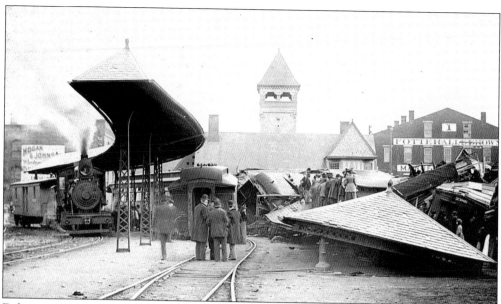

Delicate Victorian ironwork and open platforms were no match for this runaway train. The accident occurred on May 7, 1893, at the Big Four station in Lafayette, Indiana. Below is the station in a happier moment in 1910.

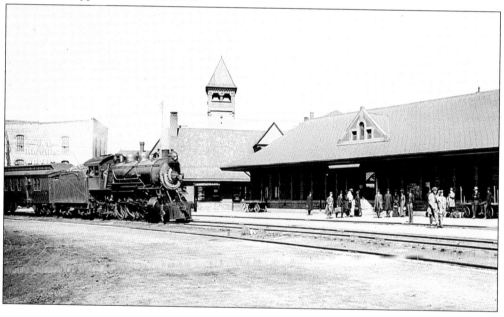

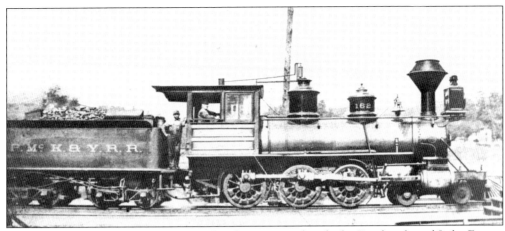

The Pittsburgh, McKeesport, and Youghioghenny joined with the Pittsburgh and Lake Erie in 1884. The Pittsburgh and Lake Erie, known as the Little Giant, was only 216 miles but was a real revenue generator because of the regional steel industry. Proud owner William Vanderbilt even convinced his friend Andrew Carnegie to invest in it. There was little passenger service.

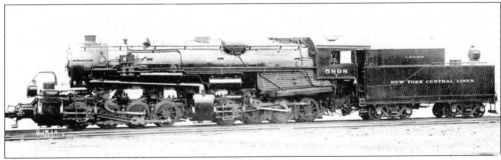

Articulated switcher Mallets assembled coal trains at the hump yard of the Pittsburgh and Lake Erie's Cleveland Division. This one was built by Alco in 1913. Alco was organized in 1901 when seven builders merged with the Schenectady Locomotive works to compete with Baldwin, the premier builder. Along with Mallets, Alco built Challengers, Niagaras, and the first streamlined steamer—the Hiawatha.

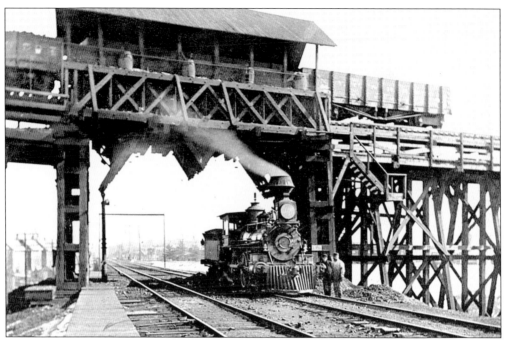

An engineer and fireman stand beside sturdy little No. 65, sunning itself beyond the Elyria Junction coal dock on the Toledo East Division. Once common on the American railroad landscape, these docks were replaced with smaller facilities as hydraulic and lifting techniques improved. This photograph was taken on February 25, 1904. (Courtesy NYCSHS; R. L. Remusat collection.)

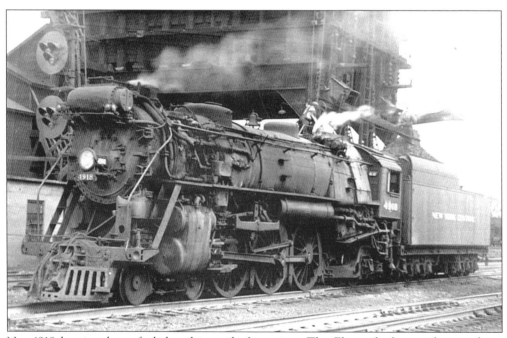

No. 4918 has just been fueled and is ready for action. The Elesco feed water heater above the boiler front preheated water and introduced it into the boiler, reducing energy use and improving efficiency.

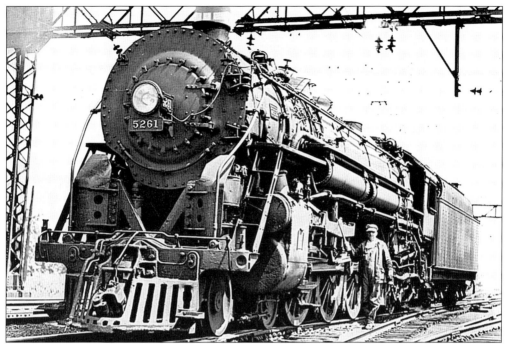

The Hudson, long considered among the most attractive engines ever, drew attention when barreling along the river they were named after. Among the elite passenger trains they handled were the 20th Century Limited, the Knickerbocker to St. Louis, the Ohio State Limited, and the Empire State Express. This photograph of No. 5261 under the C.U.T. caternary was taken by Andrew Young. (Courtesy NYCSHS.)

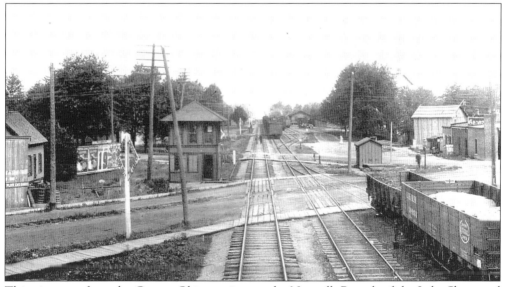

This view east from the Genoa, Ohio, station on the Norwalk Branch of the Lake Shore and Michigan Southern Railway was taken on July 6, 1906. The Lake Shore and Michigan Southern was an important part of the Central's Water Level Route, extending operations along Lake Erie's southern shore and across northern Indiana. The line is now split between CSX and Norfolk Southern. (Courtesy NYCSHS.)

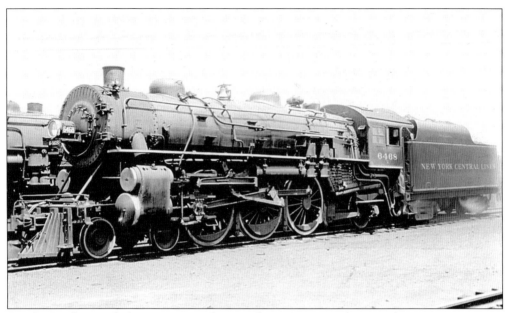

A 4-6-2 Pacific is ready for action somewhere on the Big Four. Pacifics were the preeminent power on some railroads, handling both passenger and freight trains on main lines and branches.

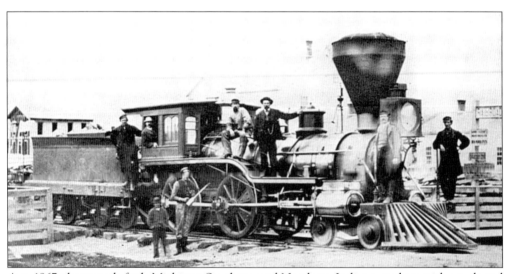

A *c.* 1867 photograph finds Michigan Southern and Northern Indiana workers with an altered 4-4-0 (the main drivers were originally larger). The little railroad carved its way through the dense Midwest forest starting in 1855. Financial woes almost sank it, but it prospered from Civil War trade and later from the westward flow of immigrants. In 1869, it was absorbed by the Lake Shore and Michigan Southern. Vanderbilt gained control in 1877.

Steam engines are in various stages of completion along the erecting floor of the Collinwood, Ohio, shop. Tons of iron and steel went into these thoroughbreds. (Courtesy NYCSHS; H. Lansing Vail Jr. collection.)

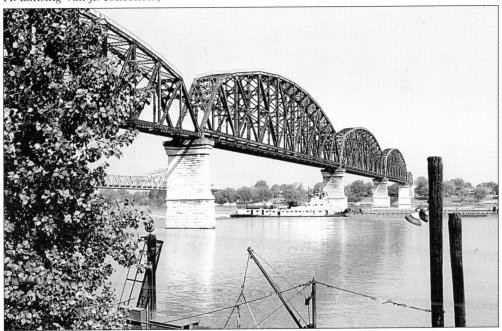

The spectacular Big Four bridge over the Ohio River was built in 1929 by the Louisville and Jeffersonville Bridge Company and is seen here around 1984. The 547-foot-long span, supported on concrete and masonry piers, uses three Parker and three Baltimore through trusses. It was abandoned after the Penn Central merger. (Courtesy HABS.)

Self-propelled motorcars such as this Brill were common on many branch lines. This one is seeing its last day of passenger service on the Alliance Branch at Dillonvale, Ohio, on May 31, 1940. Brill was founded in 1868 as a manufacturer of horsecars, trolleys, and car frames. (Courtesy NYCSHS; Dr. Louis A. Marre collection.)

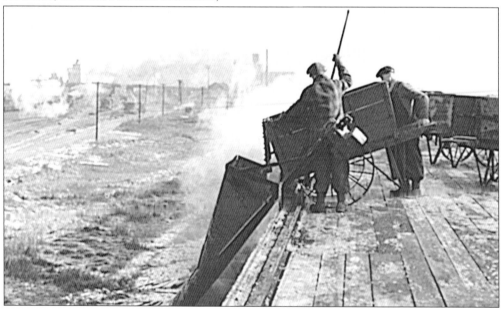

A refrigerator car is being filled with ice sent down the icing station platform at the Indiana Harbor Belt Railroad freight yard. Formed in 1907, the railroad consisted of 320 miles of main line, sidings, and yard track running between Chicago and its headquarters in Hammond, Indiana. The Central gained control in 1911. This World War II photograph was taken in January 1943 by Jack Delano. (Courtesy Library of Congress.)

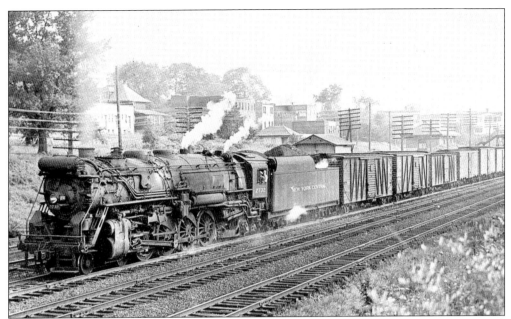

A Mohawk pounds westward with wartime freight at Teaneck, New Jersey, on August 18, 1945. These giants of the high iron saw dual service, being assigned Great Steel Fleet duties. Lima and Alco would build 600 of them. Known as Mountains on other lines, the Central named theirs after the Mohawk River they often steamed along at 80 miles an hour. Some used long haul tenders that held 43 tons of coal. (Courtesy NYCSHS.)

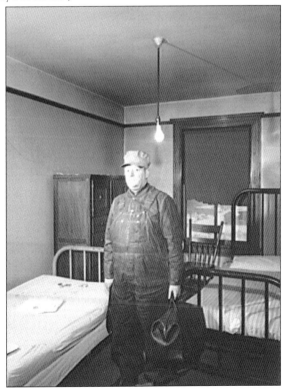

Photographer Jack Delano took many poignant photographs of railroaders during World War II for the government. One gains some sense of the loneliness of railroad life as E. S. Devine, fireman on the Indiana Harbor Belt (IHB) and Michigan Central, stands in his room at the Railroad YMCA. (Courtesy Library of Congress.)

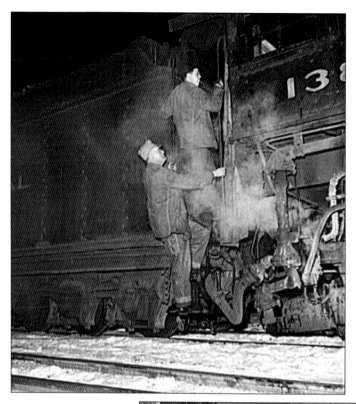

Wartime demands required grueling schedules. An engineer and fireman, after a full day's work and brief rest, return to the IHB yard just after midnight for another run in this photograph by Jack Delano. (Courtesy Library of Congress.)

Jack Delano's photographs are representative of many railroads. Here a weary yardmaster takes a break after a long day overseeing freight operations on the Central's IHB in 1943. (Courtesy Library of Congress.)

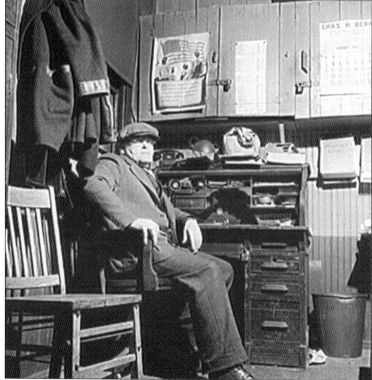

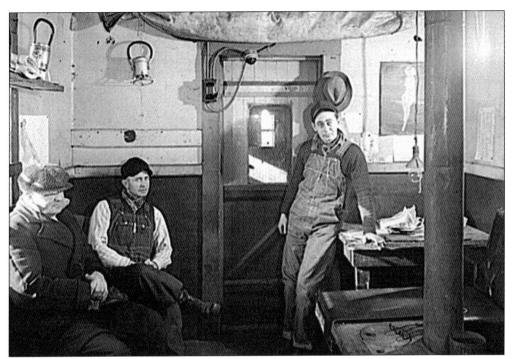

Switchmen keep warm inside the freight office, waiting for the next section to come over the hump yard in Calumet City, Illinois, in 1943. Hump yards are built on man-made hills. Cars are released at the top, and gravity sends them down the incline through a ladder of switches. Each car is then directed to its proper track for assembly into a train. (Courtesy Library of Congress.)

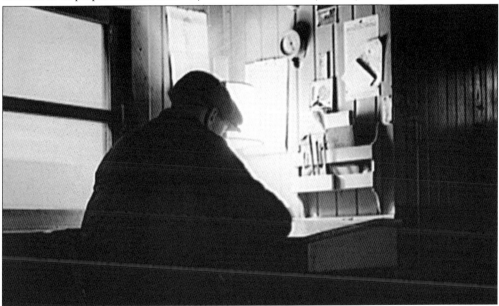

With his train safely heading down the IHB main line, conductor Cunningham turns to some paperwork as twilight moves across the railroad yard. The ticking of the office clock and brisk January winds may be all that disturb his solitude. This 1943 photograph was taken by Jack Delano. (Courtesy Library of Congress.)

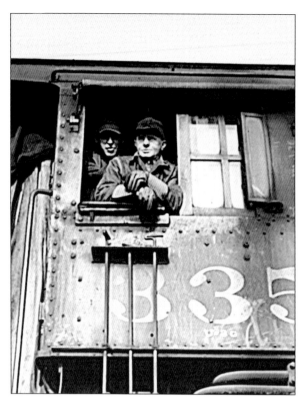

The engineer and firemen of IHB locomotive No. 335 observe activity in the yard in this 1943 photograph by Jack Delano. The Central made sure its affiliate had the best equipment. This included 0-8-0 switchers and Mikados for the main line. Note the engineer's heavy gloves. All those valves and handles could get hot. (Courtesy Library of Congress.)

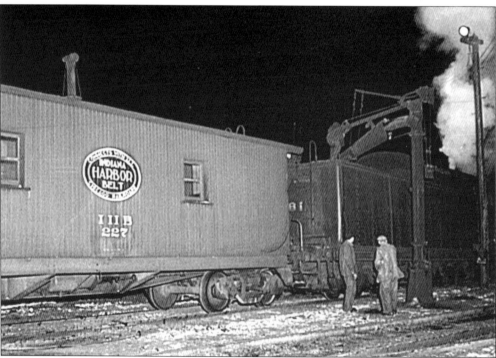

Freight operations continue late into the night at the Calumet City, Illinois, yard in this 1943 photograph by Jack Delano. (Courtesy Library of Congress.)

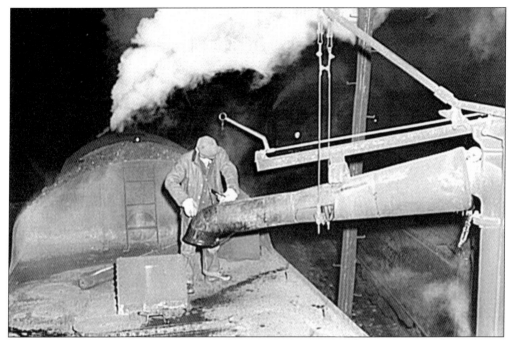

After making a delivery to Hammond, Illinois, the locomotive has stopped at the Calumet City yard to take on water and coal before heading back to Franklin Park in Jack Delano's 1943 photograph. (Courtesy Library of Congress.)

Two yard men retire to the warmness of their caboose after shunting cars all day in this photograph by Jack Delano. These "traveling homes" were usually well tended. Some had lace curtains, easy chairs, and family photographs on the walls. Cooking became legendary, with homesick crews serving up everything from ham and eggs to full Thanksgiving dinners. (Courtesy Library of Congress.)

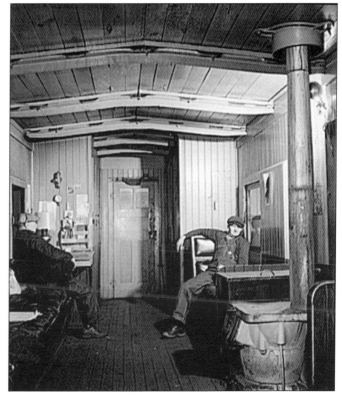

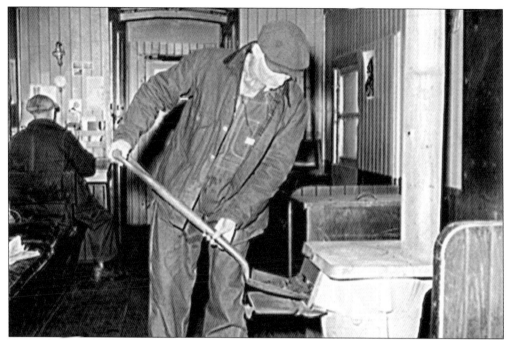

Orders have come from the dispatcher to pick up a train. It is a bitter cold January day in 1943, so the brakeman gets a good fire going in the crew's caboose stove. Early cabooses were modified boxcars. Improved suspension systems, feather beds, and running water made things somewhat more tolerable. (Photograph by Jack Delano; courtesy Library of Congress.)

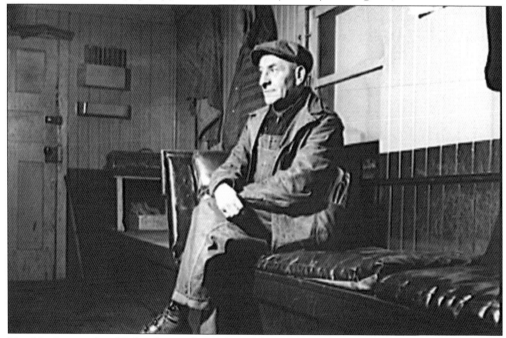

Head brakeman Lee High relaxes after a day of directing trains out onto the main line and off to other classification and hump yards in this photograph taken in January 1943 by Jack Delano. (Courtesy Library of Congress.)

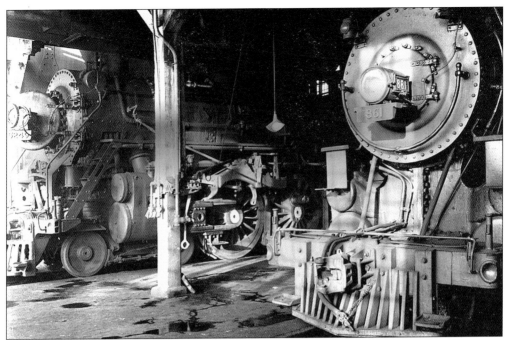

Maintenance work is being done on engines inside the Harmon roundhouse. (Courtesy Jeff Hands.)

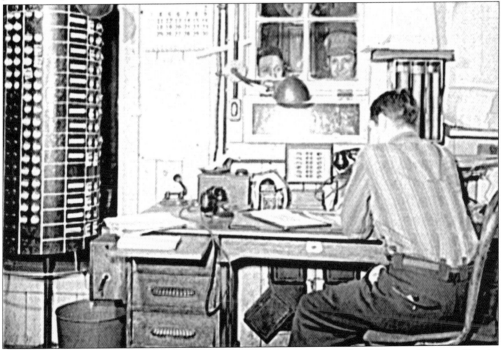

The engineer, fireman, and other engine crew have reported to the IHB roundhouse office in 1943 to learn what engine they are assigned for the day's orders. The cylinder to the left is a pool board containing the names of crewmen and the order and shifts they will work. This photograph was taken by Jack Delano. (Courtesy Library of Congress.)

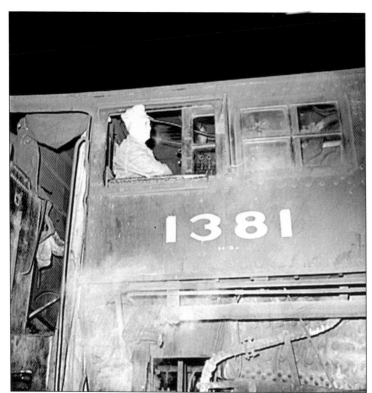

The engineer, with hand on the throttle, watches the signals ahead in preparation of a night run in this Jack Delano photograph. The New York Central engine had seen service elsewhere before coming to Indiana. (Courtesy Library of Congress.)

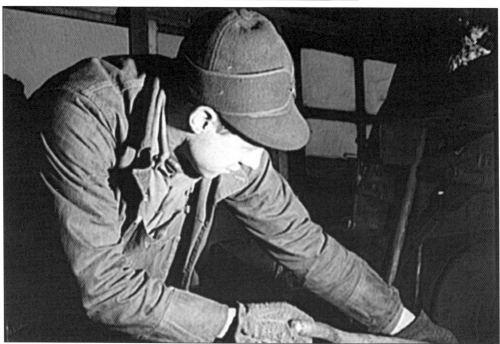

Fireman Larry Adams maintains the fire in his IHB locomotive in this 1943 photograph by Jack Delano. Larger engines had automatic stokers that fed coal from the tender into the firebox. (Courtesy Library of Congress.)

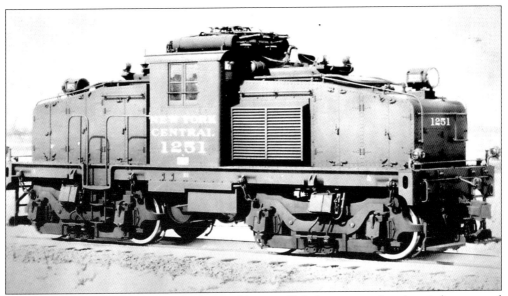

This little 600-volt brute weighed a hefty 100 tons. GM electric steeple-cab switchers started service in New York City's electrified zone in the 1920s. The first electric was built in 1837 in Scotland and was powered by galvanic cells. This unit is electrically driven, drawing power from an overhead source or third rail as compared to diesel electrics that generate their own power. (Courtesy Rochester Chapter NRHS.)

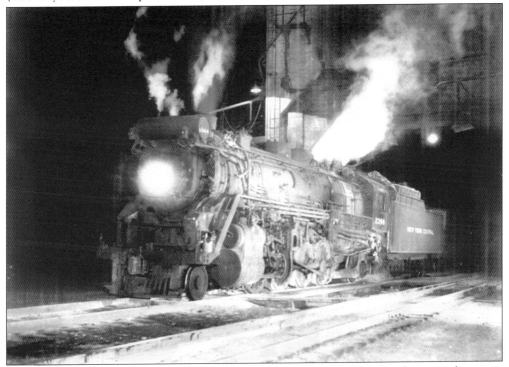

A Pacific gets its coal load topped off, probably outside Cleveland, Ohio. Pacifics reigned supreme between 1907 and 1926 until longer trains and heavier cars led to development of the Hudson and other classes.

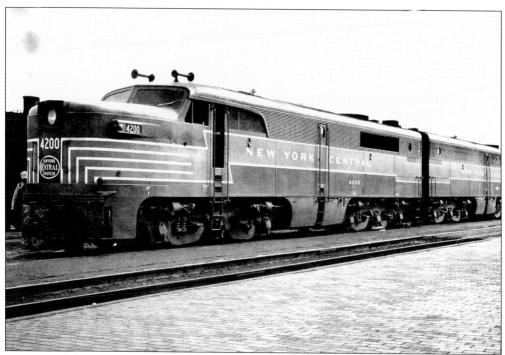

Impressive lightning bolt graphics adorn a class DPA-2A and B unit photographed at Elkhart, Indiana, by Robert Schell. Diesels were slowly replacing the old steamers when the photograph was taken in the late 1940s. (Courtesy NYCSHS; Robert G. Spaugh Sr. collection.)

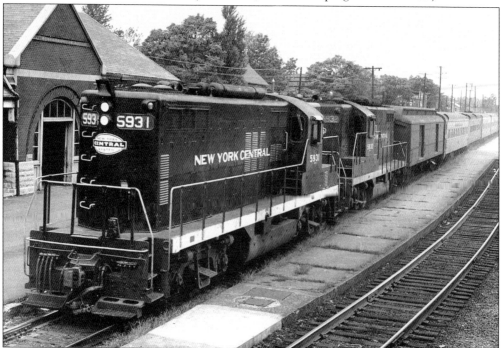

The Southwestern Limited stops at Terre Haute, Indiana, on September 2, 1963. The two GP-9 units were built by EMD. (Courtesy NYCSHS; Louis A. Marre collection.)

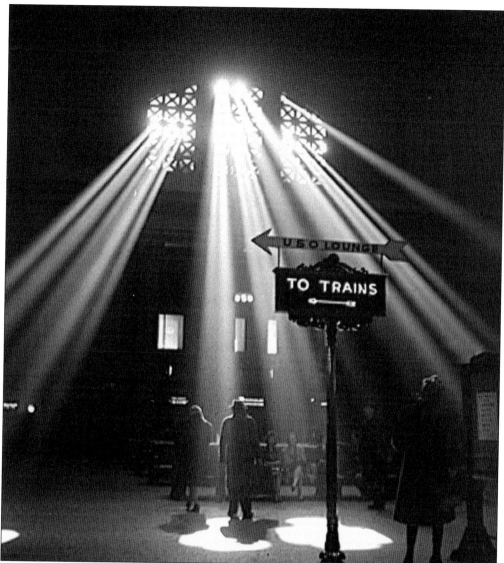

The Michigan Central was one of four contributors to Chicago's Union Station. The monumental neo-classical structure opened in 1925. The "Great Hall" waiting room is considered one of America's greatest interior spaces. It ranked up at the top of about a dozen ambitious beaux-arts stations completed during an epic "American Renaissance" building program. It served nearly 100,000 passengers daily during World War II and is no less busy today—thankfully—serving 126,000 commuters. This Jack Delano photograph was taken in 1943. (Courtesy Library of Congress.)

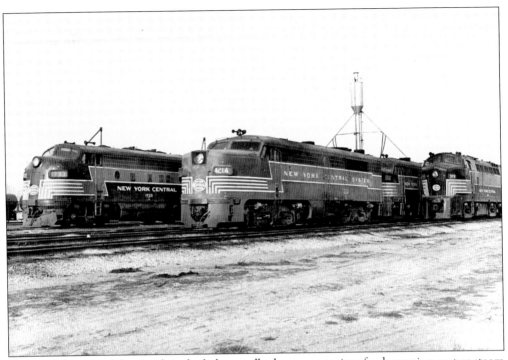

Steam-filled air, coal dust, and cinder-laden roadbeds are memories of a deepening past as steam engines have now been completely replaced by diesels in this 1960 Louis Marre photograph. An impressive lineup of three classes will carry on the traditions of service, innovation, and raw power. Heroic in lightening paint are, from left to right, an EMD class DFA-2g, Alco class DPA-4s, and a Baldwin class DFA-82. (Courtesy NYCSHS.)

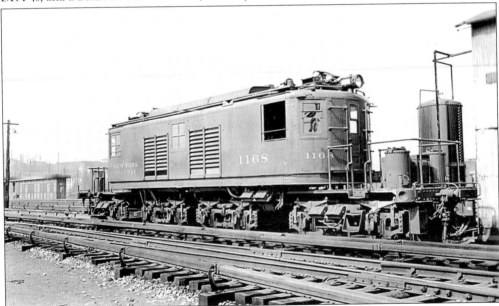

General Electric produced 36 of these T-class 4-4-4-4 electrics. Starting service in 1917, they moved trains from major city stations to suburbs to be handed over to steam engines or diesels. Powerful and efficient, each axle was powered by its own engine.

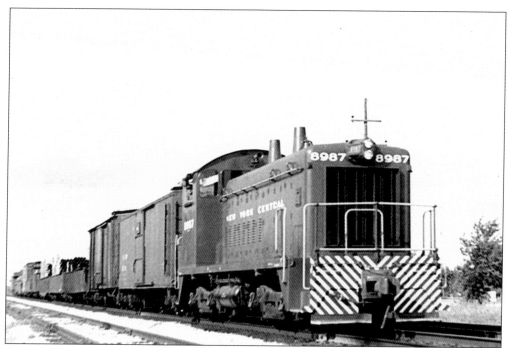

A switcher handles a small consist. Increasingly, trucking was taking its toll on railroad freight service when this photograph was taken in 1957.

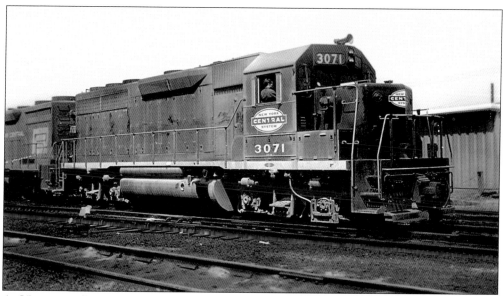

A GP-40 at Selkirk on April 27, 1970, is working with an engine lettered for both New York Central and Penn Central. The ill-fated merger would file for bankruptcy on June 21, 1970—less than two months after the photograph was taken.

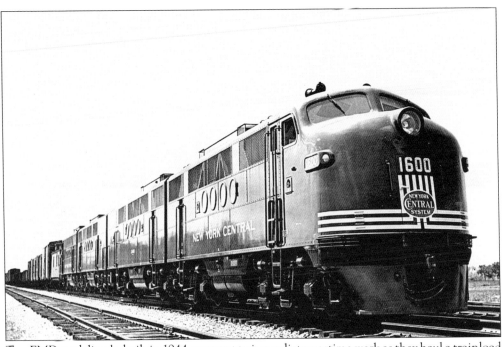

Two EMD road diesels, built in 1944, were put to immediate wartime work as they haul a trainload of war related materials. (Courtesy NYCSHS.)

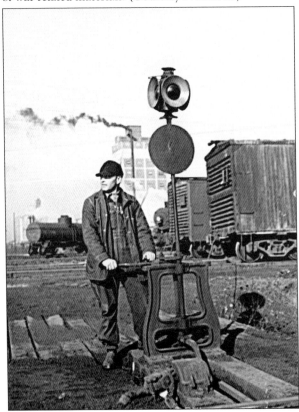

Switchman Daniel Senise prepares to throw a switch in the IHB yard in this 1943 photograph by Jack Delano. Separating and assembling trains required skill. (Courtesy Library of Congress.)

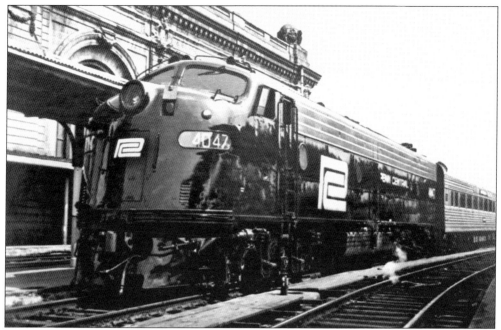

Beaten down by competitive forms of transportation, the once great New York Central's end was undignified. The equally distressed Pennsylvania Railroad's absorption of the Central through merger was a desperate attempt by both to survive in some form. The New York, New Haven, and Hartford Railroad were added in to the new Penn Central in 1969. The Central slowly disengaged itself from railroading and turned to other businesses such as life insurance. (Courtesy Rochester Chapter NRHS.)

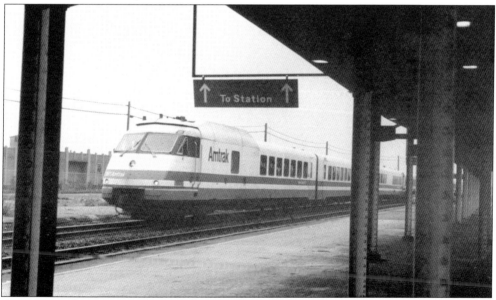

Amtrak's eastbound Empire State Express stops at Rochester in 1985 in this Ron Amberger photograph. A mostly government controlled agency, Amtrak took over much of the country's inter-city passenger service in 1971. It currently handles over 25 million passengers. (Courtesy Rochester Chapter NRHS.)

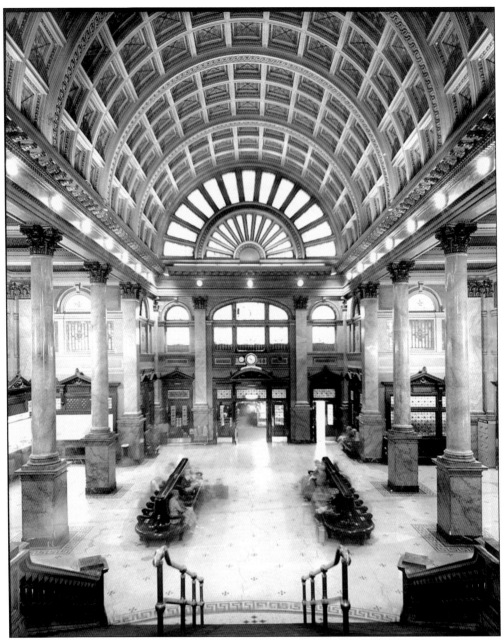

The waiting room of the Pittsburgh and Lake Erie station was modeled after the foyer in Carnegie Music Hall. It is Pittsburgh's most beautiful Edwardian interior. Erected in 1898–1901, the station has since been adapted to other uses. The richly detailed interior features a vaulted ceiling, Corinthian columns and pilasters, gilded plaster and woodwork, and massive stained-glass Palladian windows. This photograph was taken in 1983. (Courtesy HABS.)

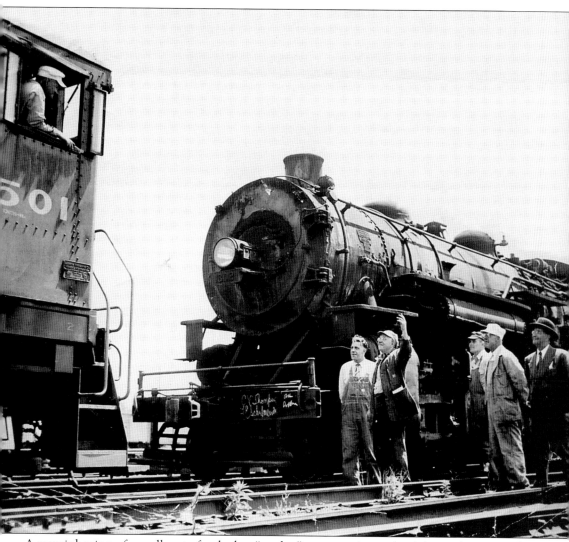

A crew is having a farewell party for the last "smoker" steam engine at the Atlantic Avenue yard in Rochester in this Ron Amberger photograph. A new diesel is ready to tow it to a scrap yard. Many believe the New York Central System's glory days faded with the end of the steam era. Its rich history refuses to fade away though, the way a train whistle diminishes as it leaves a moonlit valley. Former employees along with remaining equipment, structures, photographs, and books will continue to tell its story—how it brought soldiers home to loved ones, took newlyweds on honeymoons, and transported tons of materials that helped build America. In the way of trains, it will come and go through history, letting one glimpse its powerful locomotives, classy streamliners, lonely flag stops, and grand stations. (Courtesy Rochester Chapter NRHS.)

www.arcadiapublishing.com

Discover books about the town where you grew up, the cities where your friends and families live, the town where your parents met, or even that retirement spot you've been dreaming about. Our Web site provides history lovers with exclusive deals, advanced notification about new titles, e-mail alerts of author events, and much more.

Find Your Place in History.